THE ESSENTIAL ™

Louis Comfort Tiffany

BY WILLIAM WARMUS

THE WONDERLAND
PRESS

Harry N. Abrams, Inc., Publishers

THE WONDERLAND PRESS

The Essential™ is a trademark
of The Wonderland Press, New York
The Essential™ series has been created by The Wonderland Press

Series Producer: John Campbell
Series Editor: Harriet Whelchel
Project Manager: Adrienne Moucheraud
Series Design: The Wonderland Press

Library of Congress Catalog Card Number: 99-73512
ISBN 0-8109-5828-7 (Harry N. Abrams, Inc.)

The publisher wishes to thank Ben Macklowe
and the Macklowe Gallery, New York, and David Bellis for their generous
assistance in preparing this volume.

On the endpapers: Detail of Nasturtium leaded-glass and bronze
table lamp. Photograph courtesy Christie's Images

Printed in Hong Kong

 Harry N. Abrams, Inc.
100 Fifth Avenue
New York, NY 10011
www.abramsbooks.com

Contents

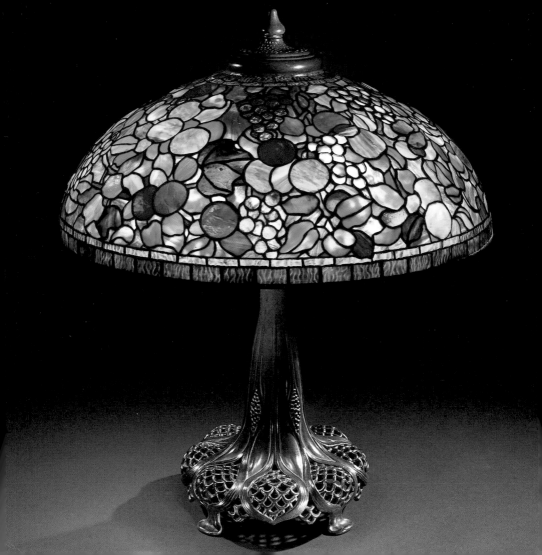

Lights, action...!

Chances are you've seen Tiffany lamps or reproductions of Tiffany lamps, and—without realizing why—you've *known* instinctively that they were Tiffany. His works are quickly recognizable and, for more than a century, have been among the most coveted, desirable forms of art glass. But why are people enamored of Tiffany glass, and why have Tiffany objects become such hot collector's items? Read on; his story will amaze you.

Sound Byte:

"I can't justify spending 20 grand on a truck. But on a Tiffany stained glass window? If I could get one for 20 grand, I could completely justify that."
—BRAD PITT, actor, 1995

Golden Child

Although **Louis Comfort Tiffany** (1848–1933) was not born with a *silver* spoon in his mouth, he was born into a family that made *golden* spoons. His father, **Charles Lewis Tiffany** (1812–1902), had founded Tiffany & Co., the luxury-goods business that defined good taste and integrity in 19th-century America and that remains today one of the world's preeminent purveyors of jewelry and luxury accessories. Louis's father, ever the hustling businessman, had expected his son to

succeed him in the family business, but the young Tiffany had other plans: He had artistic instincts and wanted to become a painter, even though he would eventually work as an interior decorator and then become the world's greatest designer and manufacturer of art glass. The breathtaking variety of mediums in which he worked included glass windows, lamps, vases, mosaics, enamel, pottery, jewelry, and "fancy goods" (eg., bronze desk sets). As we'll see, he was one of the first Americans to work within the style known as **Art Nouveau**.

Tiffany Favrile
glass vases,
lava vase, and
agate

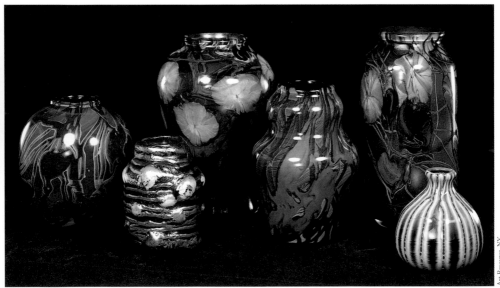

A Titanic Talent

Meet Louis Comfort Tiffany, the artistic genius who built mansions, designed dozens of interiors, created thousands of windows and lamps, and manufactured tens of thousands of blown-glass vessels, all bearing the imprint of his personal talent. He was known for having:

- a greater connection with his artistic instincts than with the entrepreneurial skills needed to run a company;

- a desire to bring beauty into every home in America, which led ultimately to the mass production of his products;

- extremely high standards—for himself, his employees, and his family;

- a ferocious inner drive, an insatiable appetite for work, and an obsession with perfection.

A Life in art

And so the story begins: Louis Comfort Tiffany was born in New York City on February 18, 1848, to Charles

BACKTRACK:
ART NOUVEAU (1890–1920)

Although known as *Jugendstil* in Germany, *Sezessionstil* in Austria, *Modernista* in Spain, and *Stile Liberty* or *Stile Flore-ale* in Italy, *Art Nouveau* is the general term applied to a highly varied movement that began in Europe and became popular internationally by the end of the 19th century. Art Nouveau achieved its greatest effects through fanciful experiments with curvilinear, floral, tendrilous, S-shaped linear ornaments (commonly called *whiplash* or *eel* styles) to create undulating enclosures of space.

The widespread use of iron and glass in Art Nouveau buildings found expression in Paris in such structures as the Montmartre church of Saint-Jean L'Évangéliste (1894–1904), the Paris Métro (c. 1900), and the Samaritaine Department Store (1905), near the Pont Neuf.

Louis Comfort Tiffany was among the first to express Art Nouveau in the United States.

Lewis Tiffany and his wife, Harriet. It was an age of growing crisis in America over the issue of slavery, and of political turbulence abroad, of technological upheaval, and an unparalleled hunger for wealth. Four days after Tiffany's birth, workers and students set up barricades in Paris, their protest ignited by agricultural and industrial depression in France. By 1861, when Tiffany was 13, America was engaged in the Civil War.

The young Tiffany was headstrong and contrary. From an early age, he enjoyed drawing and painting, and was driven by his desire to fill the world with beauty. Surrounded by the raw materials of his father's business—bars of gold and silver alongside uncut diamonds, rubies, and emeralds—he found painting more thrilling than selling jewels.

His father, on the other hand, was anxious for Louis to enter the family business. A savvy businessman, Charles Tiffany had made certain that his firm, Tiffany & Co., took advantage of the opportunities offered by the era. He had acquired gems in Europe during this time of crisis, as revolutions spread throughout the continent in the late 1840s. (As late as 1887 he would buy some of the French royal jewels.) When the transatlantic telephone lines were laid down in 1858, Tiffany & Co. profited from the new technology by selling pieces of the cable as souvenirs. In 1861, President Abraham Lincoln delighted his wife

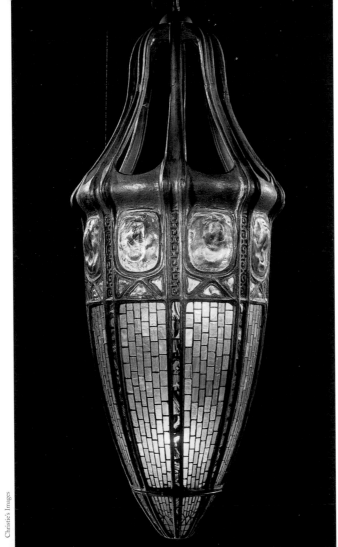

Favrile glass and
bronze turtleback
tile chandelier hall
lantern

Amethyst and Seed Pearl Sautoir. Pendant set with an oval-cut amethyst, within a circular-cut amethyst, seed pearl, and white and yellow gold filigree frame, suspended from a white and yellow gold fancy link. By Louis Comfort Tiffany for Tiffany & Co.

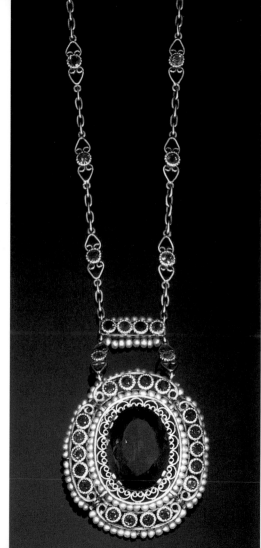

with pearl jewelry from the firm, and during the Civil War, Tiffany & Co. turned its jewelry-making skills toward the war effort, supplying swords and military accessories, and making a handsome profit in the process.

We'll show him!

Like Charles, L.C. had a fiery personality to match his head of red hair. He was a moody, restless child, frequently in trouble at home. But he inherited his father's entrepreneurial will and intense focus on quality, even though he would express himself in the realm of fine art rather than in his father's strictly profit-driven arena of commerce. His parents decided that the "cure" to his rambunctiousness and lack of desire to enter the family business was to send him off to the Eagleswood Military Academy in Perth Amboy, New Jersey, for a disciplined education. Thus, in 1862 he left for the Garden State.

Alas, he became homesick and unhappy, and apparently could not be molded into the heir-apparent that his father had hoped for. In 1865, at age 17, Louis left Eagleswood. The Civil War was over and he wanted to head for Europe to draw and absorb the culture.

Louis Comfort Tiffany as a student

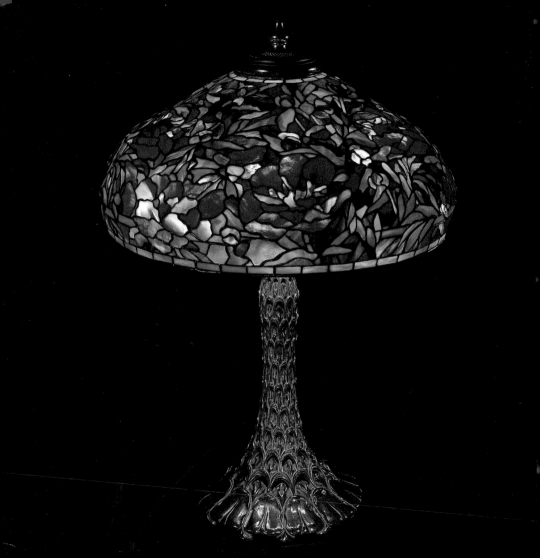

FYI: Tiffany diamonds or Tiffany lamps?—To avoid confusion, here's a summary of the various "Tiffany" companies whose names you'll see in this book. In 1837, Charles Tiffany left Connecticut for New York City and, with John B. Young, founded a stationery and fancy-goods store. They soon expanded it to include jewelry and silverware, and in 1841 named the business **Tiffany, Young, & Ellis.** In 1848, the firm began to manufacture jewelry, and by 1850 they had opened a branch in Paris. Tiffany adopted the standards of English silver in 1851, thereby establishing the term *sterling* in the United States. In 1853, he obtained sole control of the firm, which was thereafter known as **Tiffany & Co.** (The word *Company* is almost always abbreviated as *Co.*) In 1879, his son, Louis Comfort Tiffany, founded the interior design firm **Louis C. Tiffany and Associated Artists.** It disbanded in 1883 and was followed two years later by his **Tiffany Glass Company.** The company changed names in 1892 to the **Tiffany Glass & Decorating Company** when L. C. opened his own glass factory in Queens, New York. Eight years later, the business was renamed **Tiffany Studios.** In 1918, he established the Louis Comfort Tiffany Foundation. So when you think of Tiffany diamonds, think Charles Lewis Tiffany (the father) and when you think of Tiffany lamps and stained-glass windows, think Louis Comfort Tiffany (the son).

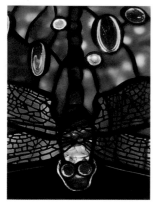

Christie's Images

Christie's Images

HOW TO IDENTIFY TIFFANY GLASS

Look for the following features and you'll be well on your way to identifying an authentic Tiffany creation:

- **gemlike colors:** deep ruby-red blossoms, emerald-green leaves, sapphire-glass skies. The colors in Tiffany glass, while never glaring, are never muddy, but are always clear, sharp, and bright.

- **use of nature for inspiration:** Dragonflies, magnolia blossoms, and wisteria vines inspire and decorate his lamps and windows. Tiffany treated glass like a natural material and let it flow and mold itself into characteristic forms in a way that is true to the material.

- **elevation of accidental effects and imperfections to the status of art:** At a time when many glassmakers sought perfection in the form of increasingly crystal-clear glass, Tiffany prized the streaky colors and other imperfections of common glassware, and sought to encourage and reproduce the random and accidental events that happen so frequently in the glassmaker's art. For example, he created a crackled window glass known as *confetti glass* that seems composed of the sweepings of shards of glass from the factory floor.

- **reliance on small parts brilliantly composed to create larger, sometimes giant, structures:** The small parts come together as stained-glass windows, lamps, and mosaics. The result: pleasing contrasts of scale.

- **textured surfaces and atmospheric layers:** These range from rough effects (such as glass that imitates pebbles and drapery folds) to smooth, blown-glass vessels that feel like

silk, to stained-glass windows with overlapping layers of glass that create the appearance of fog, mist, or haze.

- **melted effects:** Details in Tiffany glass not only *appear* to dissolve or liquefy into each other, they actually *were* fused together during the molten-glass forming process at high temperatures.

- **delicacy:** Tiffany realized that the beauty of glass derives partly from its perceived fragility. An example: painfully long stems on his flower-form vases make them seem as if they could snap in half under their own weight.

- **movement:** Swirling storms of color in the vases, windswept patterns in the lamps, and the play of sunshine on the stained-glass windows all work to produce a sense of motion that keeps Tiffany's work alive 100 years after it was made.

- **extreme focus on beauty and quality:** The glass had to look splendid and be made well or it was not worth creating. Tiffany was known to smash window panes under construction in his studio if he felt the color was wrong.

- **theatrical flair:** Tiffany used ensembles of materials and furnishings to create theatrical environments in locations as diverse as the interior of the White House and a room for military veterans, complete with heavy chains, eagles, and the suggestion of a harem. Frequently, beauty for Tiffany rested in the ensemble.

- **signature:** Tiffany's signature, at the bottom of his lamps, is easily (and often) faked. Therefore, experts rarely use his signature as an identifying feature of genuine Tiffany glass. They rely on the factors listed above.

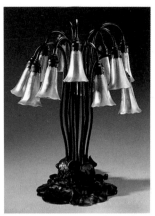

Christie's Images

OPPOSITE TOP
Detail of a poinsettia leaded glass and bronze floor lamp

OPPOSITE BOTTOM
Detail of a dichroic dragonfly leaded-glass and bronze floor lamp

ABOVE
A 12-light lily Favrile table lamp

Europa (New York) Europa

OPPOSITE
Renaissance
revival leaded-
glass and gilt-
bronze table lamp.
31½" (80 cm) high
x 24" (60.4 cm)
diameter of shade,
with finial

While overseas, Louis sketched a variety of local people and scenes, but since he lacked formal training as an artist, he was not successful with human faces. As a result, he focused mostly on landscapes and on scenes in which the figure faced away from the viewer.

On his return to New York City in March 1866, he made the formal decision to become an artist and enrolled at the National Academy of Design in New York. Luck smiled on him the next year when a friend introduced Tiffany to the Tonalist landscape painter **George Inness** (1825–1894), who painted in a soft, mystical manner with a narrow range of colors. Louis began to frequent Inness's studio on Washington Square and was inspired by the older artist's personal interpretations of nature, his ability to arouse an emotional response in the viewer, and his focus on light and color rather than on subject matter or structure.

While taking informal instruction at Inness's studio, Tiffany met other young men with similar aspirations, as well as established professionals like **James Steele MacKaye** (1842–1894), a playwright and theater impresario who would later introduce him to the Irish playwright **Oscar Wilde** (1854–1900).

Tiffany made his second trip to Europe in the winter of 1868–69. In Paris, he visited the artist **Léon-Charles-Adrien Bailly** (1827–1877),

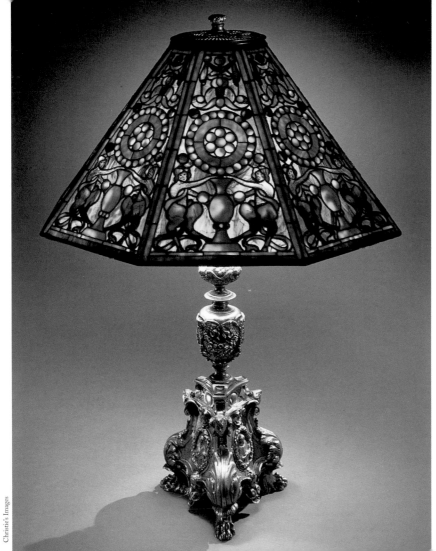

whose colorful paintings of exotic Near Eastern and North African scenery he admired greatly.

In Living Color

In 1869, Tiffany and a friend, the artist **Samuel Colman** (1832–1920), met up in Spain and set off for Northern Africa in search of unusual material to paint and sketch. Founder of the American Watercolor Society, Colman showed Tiffany the use of watercolors for making quick, impressionistic sketches as the men traveled through Morocco, Algeria, Tunisia, and Egypt. The flavor and color of exotic cultures became central to Tiffany's artistic spirit, and at the end of his career he revisited these adventures of his youth, staging a series of festivals or performances, including one set in ancient Egypt.

Sound Byte:

"When first I had a chance to travel in the Near East and to paint where the people and the buildings are also clad in beautiful hues, the preeminence of color in the world was brought forcibly to my attention. I returned to New York wondering why we made so little use of our eyes, why we refrained so obstinately from taking advantage of color in our architecture and our clothing when Nature indicates its mastership."

—LOUIS COMFORT TIFFANY, 1917, in an address before the Rembrandt Club of Brooklyn, later published in the journal *The Art World*

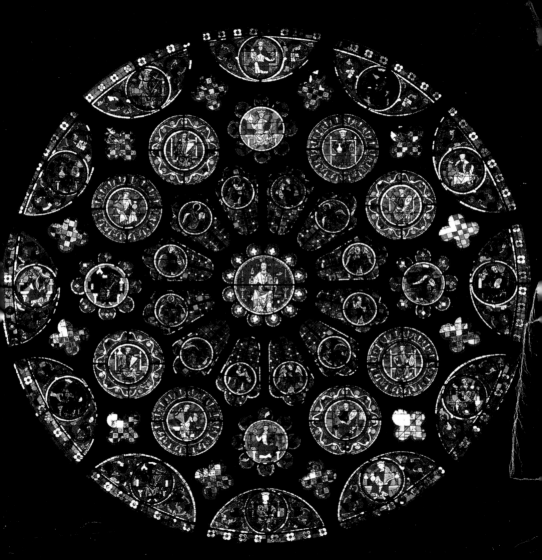

In North Africa, Tiffany felt drawn to the lavish use of bright color, especially since in New York he had seen mostly gray. He was as impressed by these colors as he had been by the richness of color he had seen in the medieval stained-glass windows at Chartres Cathedral and in other cathedrals during his trips to Europe. European stained glass seemed to glow with gemlike colors that emerged from within the glass as a stream of light rather than as colors reflected back from the painted surface of a canvas.

Until the 19th century, the windows of American churches had been designed to be practical, made with clear panes so that the passing light could brighten the space and allow the faithful, with their heads bowed downward, to read easily from their prayer books. In the process, every trace of mystery or enchantment was stripped away. Tiffany would change all of this.

Back to the Big Apple

On his return to New York in 1871, Tiffany checked into the YMCA on 23rd Street, ready to embark on a career as an artist. Almost immediately he was honored by being elected an associate member of the National Academy of Design. The connections he had made at the Inness studio, coupled with the exposure offered by his travels in Europe, had introduced him to the various artistic movements taking place in the world and he had come to believe that the study of nature

should inspire and guide art. It was as if, since the Renaissance, the arts had been defined by what they were *not* (i.e., painting was not architecture) and suddenly the various art forms were being defined by how well they could blend together. Thus, the painter **James MacNeill Whistler** (1834–1903) boldly set painting *into* architecture in his Peacock Room of 1867–77 in London. This idea of merging various art forms would have a profound influence on Tiffany as he moved away from painting per se and embraced interior design—and, ultimately, stained-glass windows, lamps, vases, and so on.

Sound Byte:

"Tiffany soon gained the reputation of being a 'live wire' who could carry out any kind of task quickly and efficiently. His impatient, and to some, overbearing ways, were, perhaps, a cover for his excessive shyness. His bright eyes, set in the shadow of heavy brows, his sensuous mouth, and strong, determined chin gave him a look of sincerity and determination that disarmed even those who disagreed with him."

—ROBERT KOCH,
Tiffany biographer, 1964

A Whiff of prestige

In 1872, Louis Comfort Tiffany became the youngest member ever elected to New York's Century Club, an elite association of talented and

privileged individuals who shared an interest in the arts. Recognition had begun to come his way in the marketplace, too, where his paintings were selling for roughly $500 each.

So-so paintings

But the sad truth was that Tiffany's paintings were not very good. He was held in esteem by his colleagues for his energy, enthusiasm, and devotion to his goals. But his canvases were second-rate at best; they lacked the mystery and aura that he had seen in the medieval windows. His talents obviously lay elsewhere, but he had not yet discovered where.

The Harvesters and *My Family at Somesville* demonstrate an easy familiarity with the *plein-air* (i.e., a work painted outdoors) style of French Impressionism, and though the painting is self-confident and capable, it does not inspire.

Sound Byte:
"One instance in time, a fragment of a happy day, nothing more."
—LOUIS COMFORT TIFFANY,
describing his paintings

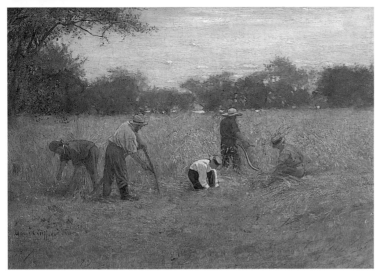

Louis Comfort
Tiffany
The Harvesters
c. 1879
Oil on canvas

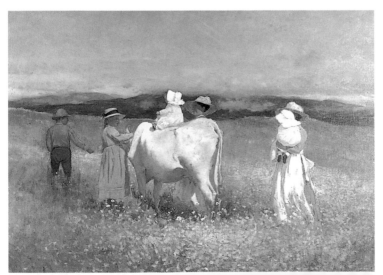

Louis Comfort
Tiffany
*My Family at
Somesville*
c. 1888
Oil on canvas

Family man

On May 15, 1872, Tiffany married the frail but energetic Mary Woodbridge Goddard and before long was the father of four children: **Mary, Hilda, Charles** (who died soon after birth), and **Charles Lewis II.** He and Mary took long walks in the natural setting of his father's estate at Irvington-on-Hudson, where he made paintings of his growing family. Doting on his children, Tiffany delighted in devising games to entertain them.

Sound Byte:

"I shall always love [Louis] because he made Mary so entirely happy—she had nearly twelve years of rare happiness on earth."

—Julia Goddard Piatt,
Tiffany's sister-in-law,
in a letter to a friend, 1884

He was now a family man and maintained close relations with his parents. The two families dined together at noon most Sundays, and Charles provided financial assistance whenever Louis required it.

Doing the Interior thing

Tiffany never stopped painting, but his career as a painter ended around the time of the 1876 Philadelphia Exposition. Though he was excited

that nine of his paintings and watercolors were on exhibit there, his attention was focused on the arts-and-crafts-influenced interiors on display at the show: They included an embroidered firescreen replete with peacocks (a subject Tiffany would adopt in his most important windows). The interiors also impressed Tiffany's friend Candace Wheeler—an embroidery expert who specialized in the production of textiles and needlework—who was interested in the links between embroidery and other forms of handiwork and how they might "encourage profitable industries among women." Her devotion to this interconnectedness led to the founding of the Society of Decorative Art in New York City, where classes were offered in needlework, tile painting, and—once she drew her friend Tiffany into the web—unbaked pottery, taught by L. C. Tiffany and his friend, the artist Lockwood de Forest, who was the son of an attorney for Tiffany & Co. De Forest collected Indian artifacts and had expertise in wood carving and ornamentation.

Alas, the weekly classes irritated Tiffany. He was a maker, not a talker, and the endless classroom discussions left him feeling unfulfilled. He

Signature of Louis Comfort Tiffany

had already concluded that he would never make it to the top ranks as a painter, so he shifted focus and decided to try his hand at interior design, a field that had always interested him.

His first company

An impatient man, Tiffany resigned in 1879 from his post at the Society of Decorative Art, determined to turn the decorative arts into a real business. He held discussions with three friends whom he wanted as partners in a new company he was forming: Candace Wheeler, Lockwood de Forest, and Samuel Colman, who collected rare textiles. That year, they formed Louis C. Tiffany and Associated Artists, naming the partnership after Tiffany because of his social prominence and access to capital.

The firm received its first commission from Tiffany's old friend, the theater owner Steele MacKaye, who invited them to design a drop curtain for the Madison Square Theater. *Hazel Kirke,* a play by MacKaye, opened the space on February 4, 1880, with newfangled electric lighting that **Thomas Edison** (1847–1931), inventor of the light bulb, had helped to install. The Tiffany landscape curtain boasted images of tall oak and birch trees

Louis Comfort Tiffany
c. 1880

Courtesy, William Warmus

rendered in velvets, while dusky silks and iridescent fabrics were woven in for atmospheric effects, as if in anticipation of Tiffany's best stained-glass windows. But the curtain was made of fabric, not glass, and it caught fire and went up in smoke before the season was over.

Influential clients

Later in 1879, the partners were hired to decorate rooms in the mansion of the pharmaceuticals tycoon **George Kemp** at 720 Fifth

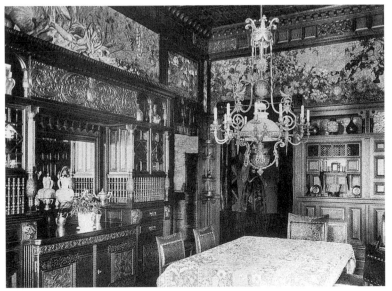

Dining room in George Kemp's residence on upper Fifth Avenue, New York City

Avenue. The success of the Kemp project attracted the attention of Charles Clinton, who was designing quarters for the Knickerbocker Greys' regiment on Park Avenue at 67th Street. The new Seventh Regiment Armory was to be a novel type of mixed-use building, more elab-

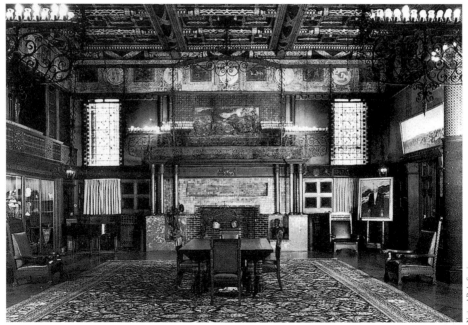

orate than the usual military drill shed, suitable for grand balls and social events. It is still in mixed use today for military functions and art and antique expositions. Louis C. Tiffany and Associated Artists was chosen to decorate and ennoble the 40 x 45-foot Veterans Room and library at the front of the structure as it faces Park Avenue, and paid a fee of $20,000—below today's prices for even the most modest of Tiffany table lamps that are offered for sale at the antique shows currently held at this very armory.

The interior created by Tiffany is today among the best preserved 19th-century spaces in America and is one of only a few interiors by Tiffany to survive. He employed architect **Stanford White** (1853–1906) of the distinguished firm McKim, Mead, and White to assist with the decorations. The result, while somewhat overbearing, was in harmony with the martial setting. The room made use of materials and objects as symbols: Oak was used as a symbol of strength, iron for its military associations, a copper kettle in the fireplace evoked memories of military encampments, and iron chains bound around the columns suggested dungeons. Spittoons, a 19th-century accessory, were placed within spitting distance of the massive chairs where aging veterans might doze off and dream of the "rewards of peace," perhaps after glancing upward at the copies of Harem windows that Tiffany had installed at the top of a small staircase—a controversial detail that drew criticism for its lascivious overtones.

OPPOSITE
Butterfly table lamp
with mosaic base
1899–1905
27³/₈" (67 cm)
high x 18³/₄"
(46 cm) diameter

Tiffany, of course, was the creative vision behind the company,
while his partners shared responsibilities for specialty work that fell
within their own areas of expertise. In what would become known
as Tiffany style, Louis embellished almost every surface with exotic,
richly detailed patterns inspired by foreign cultures. He was, how-
ever, truly American in the self-confident way in which he blended
traits from these cultures, mixing Japanese colors (e.g., pink wallpa-
per) with Islamic interlacings on the ceiling and Indian wood carvings
on the walls. His American practicality was manifested in instances
where, for example, he was inspired by barn architecture to use a door
on wheels that would slide along a track and open up to a drawing
room.

On the home front

The same year, 1879, Tiffany decorated the interior of his own home
and studio, situated on the top floor of the Bella Apartments at 48 East

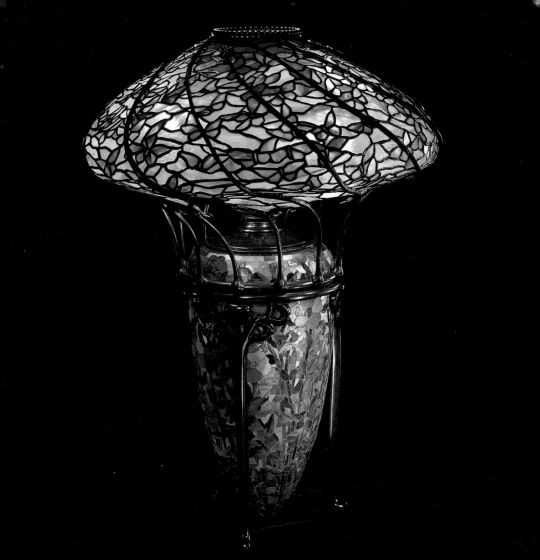

26th Street. Today such interiors cry out *clutter!* All the talk of the day about a synthesis of the arts seemed to be converging in interior design. Simplicity was out the door in a land of gigantic fortunes being made overnight by businessmen looking for a way to announce their success. An eclectic mix of decorative objects, preferably from as many eras and cultures as possible—Gothic, ancient Roman, Japanese, Chinese—all piled together as high and wide as possible, advertised status and culture. Tiffany went along with the trend because that was where the money was, but he was one of the few decorators of his time who insisted on world-class materials.

Society darlings

Louis C. Tiffany and Associated Artists owned the early 1880s. While the relatively conventional and restrained work of the decorating firms of Herter Brothers and Marcotte and Co. was in vogue among the more conservative members of New York society, Tiffany interiors were becoming widely acknowledged as possessing superior artistic qualities. Recognition came in the form of commissions from the Vanderbilts and Havemeyers and other wealthy families to decorate the interiors of the new mansions rising on the city's East Side. The meteoric trajectory of the firm is confirmed by two major projects that came to it within three years of its founding: Mark Twain's house in Hartford, Connecticut, and the White House in Washington, D.C.

First, the author

The writer **Mark Twain** (born Samuel Clemens, 1835–1910) had a keen business sense that appealed to Louis Comfort Tiffany. The first author to incorporate himself and to trademark his name, Twain had helped the Civil War hero **Ulysses S. Grant** (1822–1885) erase his debts by convincing him to publish his memoirs, which became a best-seller and earned Grant a lot of money. By 1881, the wildly popular author of *Tom Sawyer* was wealthy enough to choose Tiffany to add a little color and fantasy to the somewhat dour mansion he had acquired

Interior view of Mark Twain's house in Hartford, Connecticut c. 1882

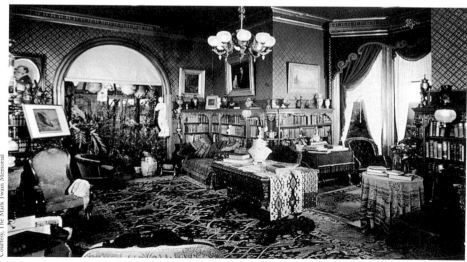

Courtesy, The Mark Twain Memorial

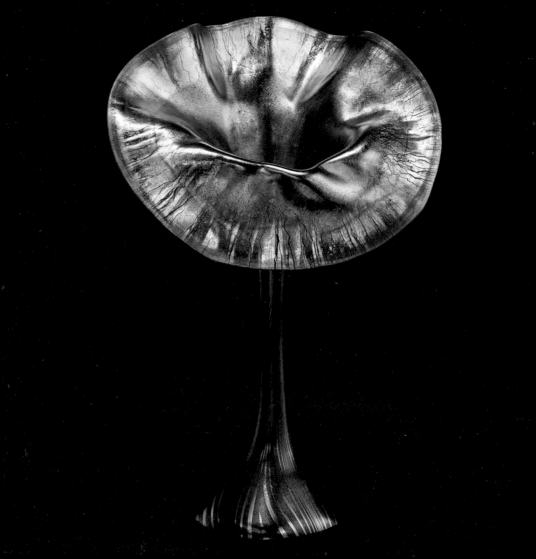

in Hartford. When Twain expressed a desire to sit before his fireplace and "watch the flames leap to reach the falling snowflakes," Tiffany conceived a fireplace with a leaded-glass window over the mantle and a double flue on the sides.

Next, the President

In 1881, **Chester Alan Arthur** (1830–1886) succeeded the assassinated **James Abram Garfield** (1831–1881) as president of the United States, but he refused to move into the White House until the tattered interiors had been renovated. Congress appropriated the "lordly" sum of $15,000 for the job, and President Arthur asked Tiffany if he would renovate the East Room, the State Dining Room, the Red and Blue Parlors, and a corridor, for about 75 percent of the price of the much smaller Armory project—and in seven weeks! Nonetheless, it was an honor and Tiffany jumped at the opportunity. The president inspected the renovation's progress every evening, as 24 loads of old furniture were removed and auctioned, and carpets tossed in the trash.

OPPOSITE
Jack-in-the-pulpit vase
1900–10
Courtesy, David Bellis

Sound Byte:
"No longer is the White House simply the home of a Republican President. Lo, it is the temple of high art."

—Anonymous newspaper clipping,
c. 1882

Most people who saw the rooms were impressed with the good taste of the new president. The major attraction was a floor-to-ceiling screen of opalescent glass on the ground floor that gave the first family some much-needed privacy. Typically subtle Tiffany touches included an off-green paint in the Blue Room that turned to robin's-egg blue under the gaslight of Tiffany sconces. The sconces themselves, some three feet wide and composed of hundreds of pieces of opalescent and mirrored glass, must have beamed like disco balls.

For some people, the results seemed more attuned to showboat decoration than to the stately mansion of the head of the Republic. A correspondent for the *World* complained that the effect was not one of monumental high art and that the fine old mansion deserved to be decorated "in a truly good style." Sadly, President Theodore Roosevelt, who found it all too much when he moved into the White House, hired architect Stanford White's partner, **Charles McKim** (1847–1909), to return the house to the style of the Monroe era, issuing orders in 1904 to "break in small pieces that Tiffany screen."

Pesky high-rollers

Tiffany delighted in his firm's high-profile commissions, but felt increasingly constrained by the petty demands of his clients, who seemed to fixate on details like the pattern of a sheet of wallpaper or

the texture of a swatch of fabric, without regard for what he was trying to achieve in the overall decorative scheme. A few, like the Vanderbilts, committed the greatest sin of all by rejecting some of Tiffany's ideas as "too expensive."

Perhaps he would have put up with these annoyances if he hadn't already been wonderfully distracted by his experiments in molten glass, which he had begun as early as 1872.

His true calling

Did glass choose Tiffany, or was it vice versa? Today, the two words seem inseparable. "Tiffany Glass" has entered the language as a term describing any type of extravagantly colored, free-form, iridescent, blown, or stained glass. Even the plastic lamps hanging over airport bars and emblazoned with product logos are identified as Tiffany!

Sound Byte:
"I then perceived that the glass used for claret bottles and preserve jars was richer, finer, had a more beautiful quality in color vibrations than any glass I could buy. So I set to puzzling out this curious matter. I took up chemistry and built furnaces."

—LOUIS COMFORT TIFFANY

OPPOSITE
Detail of peony-
leaded glass and
bronze table lamp

Although the widespread influence of his legacy would have delighted L. C., he would have been dismayed to discover that his work would one day become stylized and stripped of its daring originality. For despite the wealth he derived from commerce, Tiffany loved the pursuit of art in his work and made every attempt to elevate the commonplace to the sublime. Whenever possible, he preferred the colors of glass to those of the precious gems offered in his father's store.

Why glass?

What did Tiffany see in glass? A chameleonlike material that excelled at imitating rich and costly substances. From ancient times, glass had been used as a substitute for rare materials—the deep blue decoration in the ancient Egyptian Pharoah Tutankhamen's golden funerary mask is glass, meant to look like the semiprecious stone lapis lazuli. At the same time, Tiffany admired the indispensable, everyday uses of glass—in windows, medicine and liquor bottles, and light bulbs. It suited the practical, pioneering qualities of the country in which he worked.

Alchemist of glass

By the second half of the 19th century, glass bottles, vases, and bowls were mass-produced through industrial processes such as *mold blowing*. The goal was to continually refine the glass, improve its clarity, remove any impurities, and make everything uniform and less expensive.

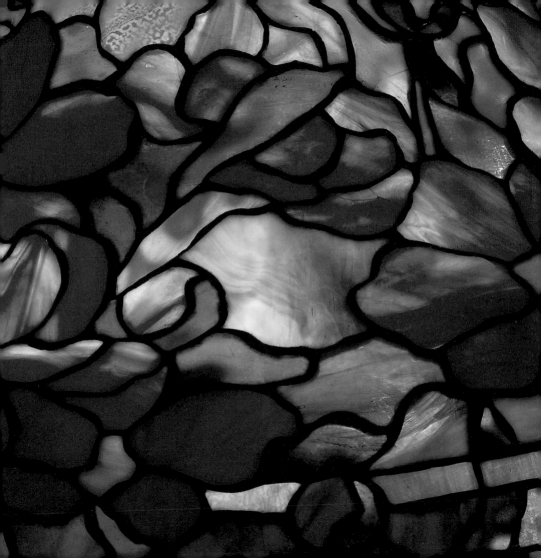

Tiffany was heard to remark that refining glass only made it weak and uninteresting.

Just as Mark Twain had understood the richness of slang when he wrote *Huckleberry Finn*, Tiffany's particular genius was to recognize that the artistic value of glass derived, in part, from the impurities that gave it character. He admired fragments of broken glass as well as ancient and medieval glasses that were corroded from age. But none of the factories of his time (all intent on refining glass to within an inch of its life) were able to provide Tiffany with the raw, crude stuff he required. The burgeoning glass artist longed to replace the increasingly sterile and overcooked glass of his era with something richer and more colorful.

The Competition heats up

From the late 1870s on, while working as an interior designer, Tiffany used more and more glass in his interiors, and engaged in a series of experiments to create new effects in glass. He examined the iridescent surfaces of ancient glasses—such as the effects that longtime burial underground had on glass—and reflected on the color effects that had been achieved in medieval stained-glass windows. He sought their secrets and ways to re-create these effects in his own glass.

He was not alone, either. The artist **John La Farge** (1835–1910), who, as a painter, had decorated Trinity Church in Boston, was also toying with new types of stained glass, and would become Tiffany's chief competitor.

Stained-glass windows

By the time the Civil War (1861–65) was over, the nation was scarred but had much to celebrate: A financially robust America was headed into its first Gilded Age and people were spending money lavishly. Industrial growth and westward expansion were in high gear. During the war, people had turned to religion as a source of strength, and when the war was over, there was a boom in church building—a phenomenon that would play a crucial role in Tiffany's success.

By 1875, more than 4,000 new churches were under construction. The design of stained-glass windows would bring Tiffany his widest acclaim and was a pursuit to which he would devote himself for nearly 50 years (until his studio closed in 1933). Stained-glass windows were an impressive way for the wealthy parishioners of a church to celebrate the memory of their loved ones in a large and colorful way, and Tiffany furnished many of these churches with the pictorial windows that their congregations desired.

Tiffany the innovator

The technique of manufacturing stained-glass windows had remained unchanged since the Middle Ages, but Tiffany and La Farge made radical innovations that forever changed the art of stained glass. Stained-glass windows had always been made from flat panes of white and

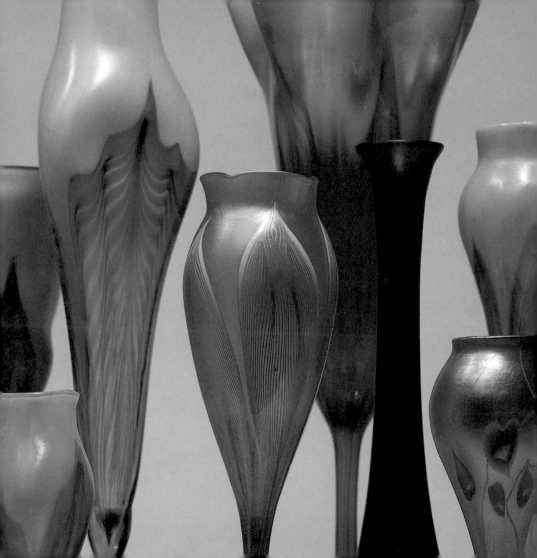

colored glass that were inserted into *cames* (i.e., slender, channeled lead rods) and held together with lead solder. Instead of using the traditional (i.e., bland) palette of colors, Tiffany developed a form of opalescent glass that exhibited a rainbowlike, milky iridescence—like that of an opal—when light shone through it.

In 1880, in an application for a patent, he described his new product as "a new character of glass in colored glass. The effect is a highly iridescent one of pleasing metallic luster, changeable from one to the others, depending upon the direction of the visual ray and the brilliancy or dullness of light falling upon or passing through the glass. The metallic luster is produced by forming a film of a metal or its oxide, or a compound of a metal, on or in the glass, either by exposing it to vapors or gases or by direct application." In 1881, Tiffany received a patent (No. 237,418) for this process. By incorporating a textured form of glass, he added a 3-D experience in the form of drapery folds, waves, and other undulating surfaces. The manufacturing process enabled the glass to be colored internally, as opposed to being painted on or modified from the outside. As a result, the glass acquired a much wider range of tonalities, textures, densities, and lines.

Tiffany integrated the new process of plating (i.e., combining layers of glass to achieve greater depth of color and a 3-D look) in his new glassworks. Plating gave him the ability to create a more dramatic and realistic sense of perspective, especially when capturing distant forms.

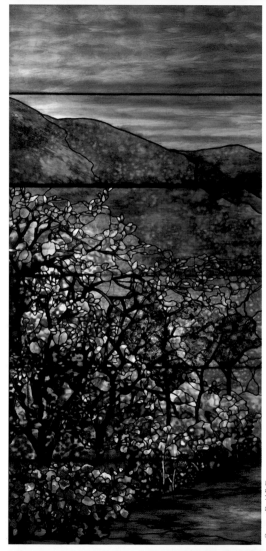

Landscape panel
c. 1900
82" (208 cm) x
31 ¹/₂" (80 cm)

The vast numbers of colored-glass sheets made it possible for him to "paint" from a "palette" of colors that was almost endless.

Tiffany introduced a new approach to the technique of leading (i.e., the thin strips of lead that gave support to the individual pieces of glass). Tiffany saw a way to integrate *cames* of varying widths and lengths into the actual design of the window, so that they served both a structural and an aesthetic purpose. This was the case, for example, when he ingeniously created cames to mimic vines or branches of a tree. By incorporating the trellis motif into the design of his windows, he not only strengthened them with the camouflaged support of the trellis's rods, but he enhanced the aesthetic complexity of the design.

Tiffany utilized every shape, size, and volume of glass in an attempt to bring realism to his windows: He fleshed in the texture of leaves with confetti glass,

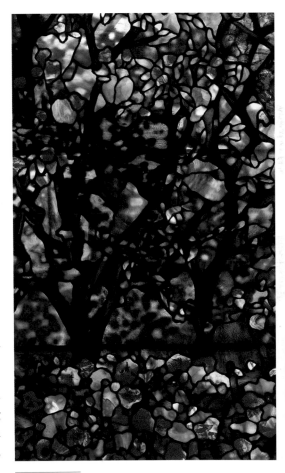

Detail of the Landscape panel

or tiny paper-thin flakes of glass; he captured the movement of water and mountain peaks with ripple glass; and he created the effect of intense sunlight that had been filtered through orange and yellow leaves through the use of mottled glass.

Paint was a no-no

Tiffany did not like using paint on glass. He saw the brush as the enemy of the glass artist, since paint dulled the glass and made it difficult for light to shine through it. He considered the act of painting on glass a failure of skill, an admission that the artist could not coax a face or some other crucial shape from the molten puddle of glass that glowed inside the furnace. Yet he continued to use paint for faces and hands, and tried to solve the "problem of paint" by minimizing the painted areas in some windows, or by attempting to fuse glassy enamel paints onto the glass sheets. However, the lead lines always remained to distract the viewer: They were simply too coarse to delineate the turn of a lip or the curve of a nose. Tiffany had better luck imitating nature with vegetable and mineral forms, such as leaves and water. It is in such details that his personal windows excel.

Big bucks from churches

Although Tiffany also designed secular windows—for schools (Yale University), public buildings (the Smithsonian Institution), depart-

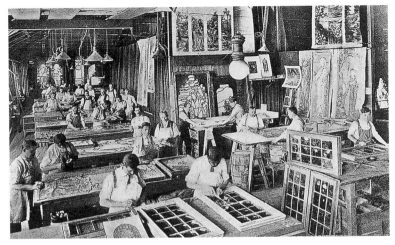

Tiffany Studios glass shop, ecclesiastical department 1913

ment stores, private homes, ferryboats, libraries, hotels, theaters, and world expositions—the church windows were his bread-and-butter business. His mission to create art glass for the entire country (and world!) jibed perfectly with his vision of art as an industry. Brooklyn boasted his windows, but so did Bath and Rome (both in upstate New York), and he installed windows in Billings (Montana), Pasadena (California), Honolulu, Paris, Edinburgh, and Adelaide (Australia).

An extensive business organization was required to support Tiffany's window-making activities, ranging from a woodworking shop that produced the huge carved frames for the most elaborate windows to a team

THE ABCS OF STAINED GLASS

OPPOSITE
Stained glass from
the Cathedral of
St. Gervais et St.
Protais, Soissons,
France. 1210–15

History: A stained-glass window or lamp consists of panes of glass of varying colors, arranged into a pattern and held together by strips of metal. Although glass windows are thought to have been a Roman invention, stained glass owes its roots to the Byzantine convention of mosaic decoration: The arrangement of many small tiles of glass, bonded to a base structure such as stone, to produce a pattern that reflects but does not transmit light. The process of making transparent stained glass matured during the Middle Ages, when the first great stained-glass windows were installed in cathedrals throughout Europe. The process has not changed much since those times. Until the 20th century, most stained glass served a religious purpose, but Tiffany helped to change that by popularizing new genres of stained glass, such as landscapes, although ecclesiastical windows made up the vast majority of Tiffany's commissions in stained glass.

Commissions: Almost all stained glass is intimately associated with an architectural context, and most windows were—and still are—made as commissions. As part of the process, the artist would hold meetings with the architects, designers, fabricators, and those commissioning the windows. Because most windows are highly complex structures, they require a skilled team of artists—not a sole artist—who work together within the artist's studio. One of the problems central to the artistic creation of stained glass is how to keep this process from stifling artistic freedom.

Process: Here's how Tiffany made stained-glass windows:

1. Drawing: A full-size drawing called a *cartoon* was required, usually derived from an initial sketch or oil painting. Sometimes Tiffany would make the sketch himself, but frequently it was assigned to a member of his staff. Two copies, or *transfers*, of the cartoon were made: One was used in glazing the window; superimposed on the other cartoon was a thin sheet of translucent paper with

heavy cut lines that indicated the positions and shapes of the glass panes (see below) and that made it possible to cut out templates for scoring the large sheets of stock glass with a diamond cutter.

2. Cutting the panes: Great skill was required to select the correct colors and textures of glass and to draw shapes that could be cut without breaking the glass. For example, it can be quite difficult to cut a deep "V" into a rectangular sheet of glass without causing the glass to break at the bottom point of the "V." It is better to design two panes of glass, each with a cut that approximates one half of the "V," and to join them together with lead cames (i.e., strips of lead with an "H"-shaped cross section).

Detail from *The Legend of the Seven Steepers of Ephesus,* Cathedral of Rouen, France. c. 1210–12

Detail from a Tiffany Oriental poppy leaded glass and bronze floor lamp.

3. Selecting the glass: Sometimes, rough fragments of glass were waxed up onto a sheet of clear glass in an attempt to prefigure the flow and relationships of colors in the finished work. Selecting the correct glass from Tiffany's huge stock of sheet glass was complex (typically, he stocked more than 200 tons of glass in some 5,000 colors). If he required glass that was meant to imitate the folds in clothing or drapery, then the folds had to flow in the right direction to fit the figures. His workers were obliged to find pieces of glass that had shaded colors in order to suggest the play of light on water, or the shadows on leaves.

4. Leading the window: The drawing that indicated the cut lines was placed on a table, and the cut panes of glass were arranged like a jigsaw puzzle. *Cames* were used to hold the panes in position and to join the entire structure together. The edges of the glass were slipped into the channels in the lead came and the lead cames were soldered together. Later, in his lamps, Tiffany employed a technique know as *copper foil* that allowed for more delicate and creative work. The edges of the panes of glass were wrapped in copper foil and laid out on the drawing of the cut lines. Molten solder was then run between the panes. Tiffany showed his genius by making creative use of the lead lines, sometimes molding them into the shape of vines, as in his *Magnolia* and *Wisteria* windows.

5. Finishing: Finally, the window was waterproofed and, for larger windows, structural metal rods or bars were attached to support the weight and keep the window from sagging when held upright. The windows were then crated for shipping, and a team of installers met the windows at the site for installation.

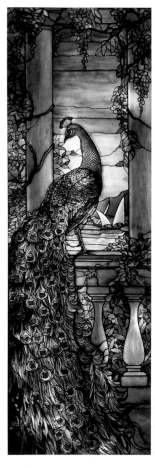

of installers trained to travel to the site and put the windows in place and waterproof them.

First the Bible, then babbling brooks

At first, the themes of his ecclesiastical windows were biblical subjects. But with time, he added lush landscapes of streams, woodlands, mountain valleys, and floral motifs (hollyhocks, irises, wisteria, foxgloves, hibiscus bushes, lilies, purple clematis, and branches of magnolia trees with their creamy-white and lavender-pink flowers). Eventually, he went so far as to remove the human figure altogether from these images, conferring a kind of religious meaning on the landscape itself. Thus, a flowing river could symbolize the passage of life of a deceased parishioner, while irises—in their pure, splendid glory—might represent the Virgin Mary.

Dazzling effects from simple Subjects

Tiffany's critics generally praised his glass—that is, the material he used and the blown forms themselves—even though they often found the subject matter of his reli-

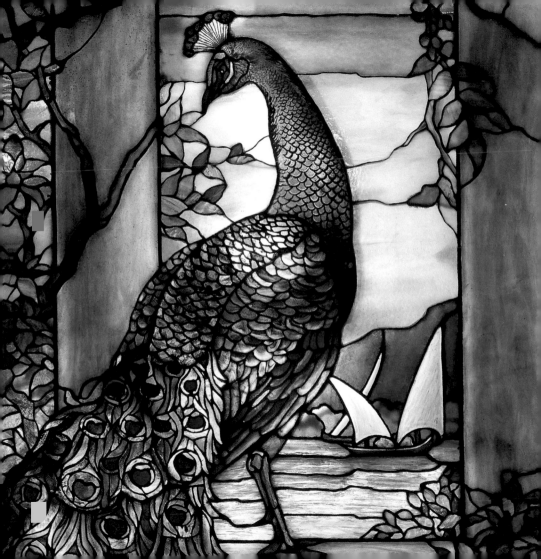

gious windows overly sentimental and out of touch with current art trends. They preferred the abstract patterns that came naturally to glass, but Tiffany knew what his market wanted. Once he had hit his stride with glass, Tiffany never looked back. He was like an alchemist who had cracked the code that turned lead into gold and he was ready to change the world. In fact, Tiffany claimed (with the authority of someone who had blown up and burned down more than one factory) to be the first modern industrial artist.

Tiffany Lamps

Tiffany made all sorts of lamps. Initially, his lamps were illuminated by gas, but he is best known for those he designed to accommodate and tame the cataract of light flowing from Thomas Edison's terrific new invention in 1879—the electric lightbulb.

PAGE 52
Landscape window with peacock
c. 1912
115 1/2" (293 cm) x 30 3/5" (75 cm)

PAGE 53
Detail from Landscape window with peacock
c. 1912

Sound Byte:

"Those of us in America who began to experiment in glass were untrammeled by tradition and were moved solely by a desire to produce a thing of beauty, irrespective of any rule, doctrine or theory. Color, and color only, was the end sought."

—LOUIS COMFORT TIFFANY,
"American Art Supreme in Colored Glass"
The Forum, 1893

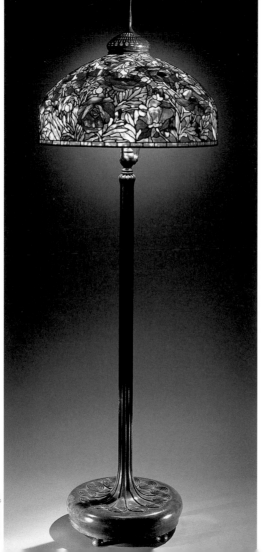

Oriental poppy
leaded-glass and
bronze floor lamp
79" (201 cm) high x
26 ½" (67.4 cm)
diameter of the shade
with "pigtail" finial

RIGHT
Lamp
department
c. 1899

OPPOSITE
Detail of lamp
showing glass
pattern

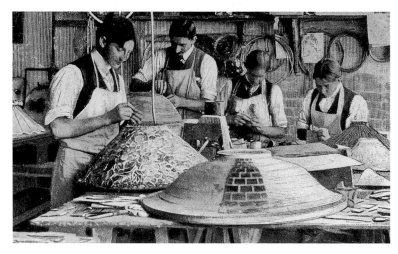

The lightbulb, which was impossible to imagine without the discovery of glass and the invention of glassblowing, inspired Tiffany to create a galaxy of floor lamps, ceiling fixtures, lamps with blown-glass shades, and the famous leaded-glass table lamps that are like sculptures of stained glass. The stained-glass lampshades were assembled on wooden molds (they looked like hemispherical bowls turned upside down) and each piece of glass was arranged following a predetermined pattern. While not mass-produced or machine manufactured, the lamps were made in multiples, a little like an edition of prints, although there is no record of the quantity of each lamp made, nor is this number indicated on the individual lamps.

OPPOSITE
Wisteria table
lamp 1900–10
28 $1/5$" (69 cm)
high x 25"
(61 cm) diameter

Unlike a print, each Tiffany lamp has a unique identity. In this sense, his lamps are more like tulips than prints: Each shade has a particular signature or "look" determined by the balance of color and texture achieved in the overall pattern as chosen by the individual artisans who assembled the shade. The process could take seven to ten days for a major design. Connoisseurs today seek shades that "pop" with color because this meant that the artist took chances or had a good eye, or maybe even that he or she was the fastest person to the storage bin that contained an especially good sheet of glass. Collectors avoid shades with muddy tones, or ones that are dull, as if made from leftover pieces of glass.

OVERLEAF
LEFT
Detail of fruit
lamp (top view)
Christie's Images

RIGHT
Detail of
Oriental poppy
floor lamp
(top view)
Christie's Images

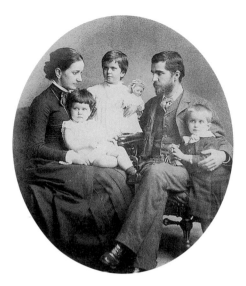

Louis Comfort Tiffany
and family
c. 1881

A Time for pause

In the spring of 1883, savoring his success with stained glass as well as with interior decoration, Tiffany arranged his first vacation in five years and took his wife and children to St. Augustine, Florida. But Mary's already frail health continued to deteriorate, and she died of tuberculosis less than a year later in January 1884, leaving the distraught Louis a widower with three young children.

A fling with Theater

Within a year, the widowed Tiffany was running with a fast crowd and was somewhat blinded by the glamour of the theater world, where he had sought refuge from the pain of Mary's death. Steele MacKaye was preparing to open a new theater, the Lyceum, and was in discussion with Tiffany's chief rival, John La Farge, to decorate the space, but Tiffany

snapped the assignment away from LaFarge by offering to do the job in exchange for a share of the profits instead of a fee. It was during this fling with the theater that Tiffany first incorporated electric lighting into his designs, when he artistically adapted the lightbulb into the production. Critics raved about the splendid new theater, but the opening play, *Dakolar* (written by MacKaye), was a failure and earned no money. Tiffany sued for payment and, for a brief time, found himself the owner of the theater.

From cultured despot to businessman

The exceptional financial loss strained Tiffany's resources to the breaking point, but the taste of high drama left him with a hunger for more, and his instincts for showmanship manifested themselves in glass-works that became increasingly theatrical.

Charles Tiffany was increasingly alarmed by his son's wild lifestyle and financial reversals. He encouraged Tiffany to reorganize his business, which was incorporated as the Tiffany Glass Company on December 1, 1885, with Louis as president. The father's somewhat offbeat solution to what he deemed to be his son's lifestyle problem was to entice Louis to build a mansion at 72nd Street and Madison Avenue, where he imagined the entire family could live together. He gave Louis a budget of $100,000. Although Charles never did move into the house, the project

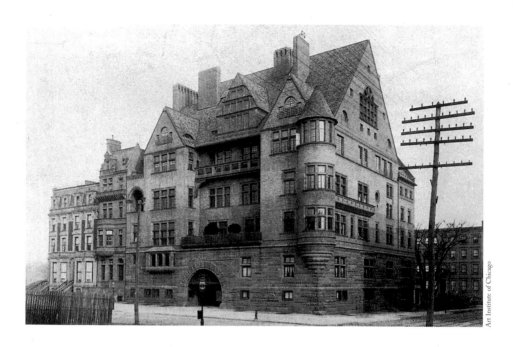

Tiffany mansion,
Madison Avenue
New York City
c. 1885

helped Louis settle down (somewhat), and when he met Louise Wakeman Knox, he asked her to marry him. The wedding took place on November 9, 1886. From all accounts she was a quiet, calm, devoted woman who provided the perfect grounding for her husband's frenetic business energies. The family would eventually grow larger as Louise gave birth to twins, Julia and Comfort, and to a daughter, Dorothy.

Paris and the "New Art"

In 1889, while vacationing in Europe, Tiffany visited the Paris Exhibition, where he was deeply impressed by the Art Nouveau glasswork of **Emile Gallé** (1846–1904). He visited the dealer Siegfried Bing, a leader in the emerging Art Nouveau style whose shop was a meeting place for artists. The two became fast friends and exchanged information about decorative art trends on their respective sides of the Atlantic. Together they forged a project whereby Bing would order and exhibit ten Tiffany windows, designed by prominent French artists—including **Pierre Bonnard** (1867–1947), **Édouard Vuillard** (1868–1940), and **Henri de Toulouse-Lautrec** (1864–1901)—and would exhibit them at the Salon du Champs-de-Mars.

Wary of competitors

Anyone working in glass at that time was forced to lease communal space at the glass factories. This made it impossible for Tiffany to protect his ideas, since other glass artists would know what he was doing. Tiffany contracted with the Heidt Glasshouse in Brooklyn to produce glass for him (1890–93), but the shared conditions made it less than desirable. By 1891, the Tiffany Glass Company was an expanding business that was almost breaking even, with an income of roughly $451,000 and expenses of $454,000. In 1892, it was reorganized once

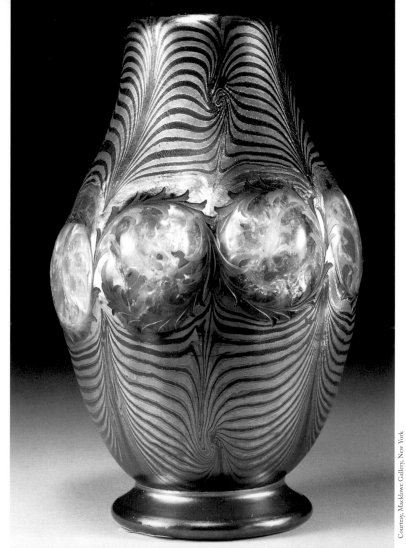

again as the Tiffany Glass and Decorating Company. Due to the growing demand for his windows, Tiffany hired a number of full-time window designers, including the Englishman Frederick Wilson (1858–1932), known for his work with liturgical subjects.

All things exotic

About this time, the actress **Sarah Bernhardt** (1844–1923) appeared in New York in the social drama *Theodora,* by **Victorien Sardou** (1831–1908), and this helped to launch a fashion for Byzantium and Byzantine-style churches. Tiffany perceived an opportunity to experiment with glass mosaics—a staple of Byzantine decoration—and for the interior of wealthy New York art collectors Louisine and Henry Osborne Havemeyer's mansion at 1 East 66th Street, he provided a thrilling gold, white, and pale-green mosaic hall with ten pillars, inspired by the Byzantine chapels at Ravenna, and a staircase like the one in the Doges' Palace in Venice. The Havemeyers wanted to display their rare artworks in a worthy setting, so Tiffany designed a Rembrandt room to house their old-master paintings, working with his associate Colman to create a brocade ceiling that evoked the feeling of glass mosaics. In one space, Tiffany suspended a golden "flying" staircase, treating it as if it were a necklace or a hanging ornament for the house. The project was completed in 1892.

OPPOSITE
Iridescent vase with window decoration

Finally, his own Digs

The year 1893 proved to be momentous. Tiffany was finally ready to build his own factory, which he located in Corona (Queens), New York, not far from the Flushing Meadows site of the U.S. Open Tennis Tournament. The factory became known as the Corona Furnaces and was a giant studio for producing art. In this regard, Tiffany paralleled the operations of Renaissance studios and ateliers and was a precursor of such large-scale studio operations as those controlled by Frank Lloyd Wright, the Bauhaus, Andy Warhol (who named his studio the Factory), and Dale Chihuly, often called the Tiffany of the 21st century.

Having already provided mosaics for the interiors of five churches, Tiffany made the groundbreaking introduction of his famous hand-blown glassware, which he called Favrile glass. Originally, Tiffany had named it *Fabrile* glass—from the Old English *fabrile*, or "hand-wrought"—to describe the hand-blown quality of his new glass (as opposed to commercially manufactured glass), but he later changed the word to *Favrile*, since this sounded better. By combining up to seven colors, drawn from different ladles, Tiffany created an endless palette of blended colors to simulate nature's ever-changing moods. He treated the glass with an iridescent surface finish that was achieved in a heating chamber, where an atomized solution of metallic vapors was

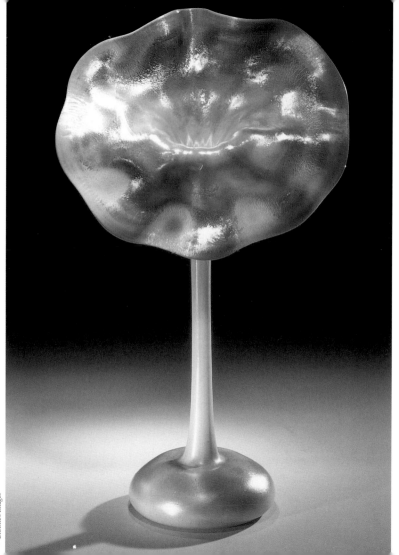

sprayed onto the surface of the finished piece. The process lent a kaleidoscopic sheen to the glass, one that became an identifying feature of Tiffany's Favrile domestic wares.

Sound Byte:

"I was there the day that we hit the colors, that we made the first vase of Tiffany iridescent [Favrile] glass. I was sent down to the office to bring Mr. Tiffany up to show him this new vase that he had never seen before. When he came up, he was so delighted—I can see him prancing around and dancing around there yet, and pulling his belt up and so on and so forth, yeah. So from that day on until they closed the company down, Tiffany's colors were all over the United States and all over the world. Every big museum in Europe and every large museum that I can think of had an exhibit of Tiffany."

—JAMES STEWART,
Tiffany master glassblower,
interviewed in 1966 by Robert Koch

Tiffany was passionate about the idea of working with blown-glass Favrile forms because, like stained glass, they offered him an opportunity to create feats of beauty that would reach a large audience. Whereas stained glass (as in the windows for churches) was like a theatrical performance that required a stage and a huge audience, the blown ves-

sels were less expensive and more easily portable, and so might reach a larger public.

Tiffany immediately realized that the blown glass was a perfect calling card for his business, and much of the first full year's production of the Corona Furnaces in 1894 went to art museums, including the Metropolitan Museum of Art in New York, the Smithsonian Institution in Washington, D.C., the Imperial Museum of Fine Arts in Tokyo, and the Musée des Arts Décoratifs at the Louvre in Paris. That year, an exhibition of Favrile glass at his Fourth Avenue showroom in New York drew enthusiastic crowds and earned him considerable international respect. *The New York Times* raved about "astonishing results... entirely novel both in color and texture...absolutely unique of their kind."

Impressed by Louis's growing success, his father made L. C. a director of Tiffany & Co. and named his son executor of his estate and heir to one third of his wealth.

Moving into Mosaics

Given Tiffany's penchant for new ventures, and as he had already enjoyed success with mosaics in his design work, it was only natural for him to expand beyond Favrile and stained glass into mosaics as an extension of his company's offerings. Mosaics consist of a matrix of small squares

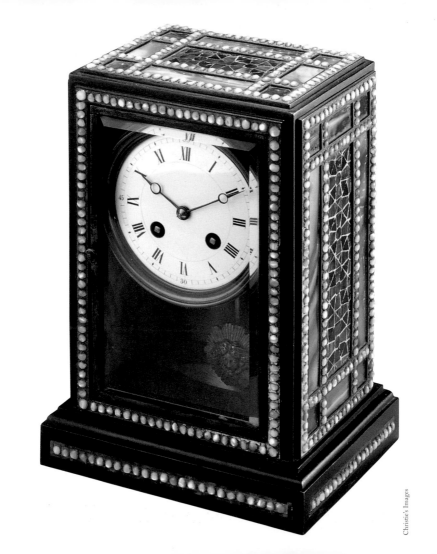

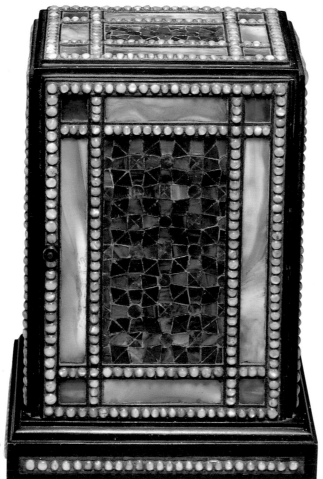

OPPOSITE
Favrile glass,
mosaic, and
bronze clock
(front view)

LEFT
Favrile glass,
mosaic, and
bronze clock
(side view)

OPPOSITE
Detail from
landscape panel
with garden and
fountain. Favrile
glass and cement
mosaic. 8'7 ½"
(262.9 cm) height
c. 1905–15

of colored glass called *tesserae* and of irregularly cut pieces called *sectiliae*. Instead of using the flat, solid-color glass pieces that traditional mosaic artists had used, Tiffany created a wide range of colors by using the innovative techniques of modeling and shading. He added a lustrous iridescence to his mosaics by backing pieces of semitransparent glass with metallic foil. This gave them the appearance of greater depth and radiance in the sunlight.

To produce a mosaic, Tiffany prepared drawings of the design and then created a small mockup that showed a section of the mosaic, with samples of the tiles glued onto it. Blue was one of his favorite colors.

His firm was commissioned to create mosaics for church floors, birdbaths, fireplace surrounds, inlaid columns, and a variety of other aesthetic purposes. Before long, mosaics had become a substantial part of his business. Tiffany's greatest achievement with mosaics was his design for the chapel that his company exhibited at the 1893 World's Columbian Exposition in Chicago. Bing had encouraged Tiffany to exhibit at the exposition, since he knew this could attract influential new clients to the firm. He was right: Tiffany's Byzantine-style chapel and stained-glass windows were major crowd-pleasers. The design consisted of a pair of brilliant peacocks, capped by a jeweled crown, and was said to contain more than a million pieces of tesserae, along with sparkling blue and gold glass gems.

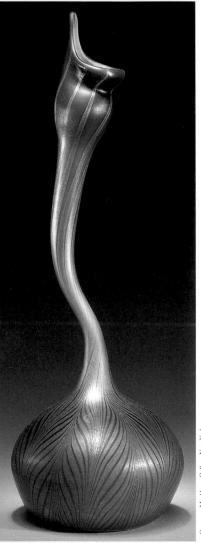

Favrile all the way

By late 1895, Tiffany was pleased with the quality and range of his hand-blown Favrile glassware. The repertoire of subjects in his windows and lamps had grown to include pure landscapes, exotic flowers and plants, birds, fish, animals, and nature in all its glory. Tiffany's lifelong passion for flowers found expression in these works as well as in the gardens of his summer home, Laurelton Hall (see page 95).

The earliest pieces of Favrile glassware reveal Tiffany's initial reliance on traditional forms for his new medium. The majority drew inspiration from the Greek wine jar, the Old English possit cup, the Roman amphora, and Chinese Ming porcelain vessels, to cite some of the shapes produced between 1894 and 1896. A few showed a tentative embrace of nature in their rather stiff but organic contours, no doubt an acknowledgment by Tiffany of the Art Nouveau movement that had begun to enjoy wild popularity at the Paris salons.

Tiffany developed a delightful range of domestic wares inspired by floral ornaments, with popular motifs that included bands of striated leaves or peacock feathers applied to an iridescent-gold or cobalt-blue back-

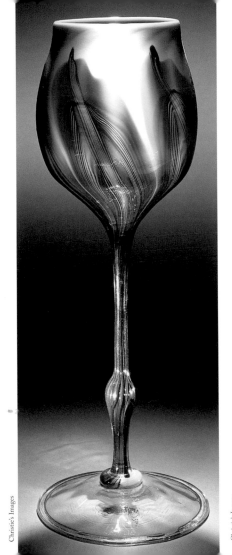

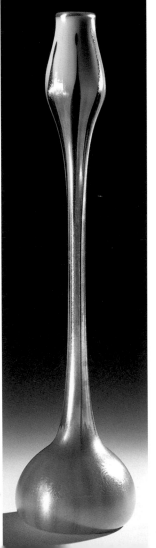

OPPOSITE PAGE
Gooseneck with
peacock feather
decoration.

THIS PAGE
FAR LEFT
Favrile glass
floriform vase
c. 1900–05
13 ⅝" (34.5 cm) high

LEFT
Favrile glass
onion vase

OVERLEAF
LEFT (page 78)
Enameled copper vase

RIGHT (page 79)
Lava vase with
crossover lava flows

ground. The breathtaking cameo-cut vases manifested *cut marks* that sliced through one or more layers of different colors of glass, with carved floral patterns such as lily pads. (The Austrian glasscutter and engraver **Freddin Kreischmann**, 1853–1898, was Tiffany's leading craftsman of this painstakingly difficult form, which could require up to four months of work per vase.) The company's series of flower-form (aka floriform) vases—willowy-form vessels designed as specific leaves, veins, or flowers with broad, fluted mouths, slender tapering stems, and bulbous feet—brought Tiffany's interpretation of the European Art Nouveau style to full expression. Early examples included narrow-mouth vases shaped like onions, or elongated buds ready to burst into bloom. In later vases, Tiffany opened up the mouth of the flowers and created exuberantly open blossoms. One of his favorite forms was the jack-in-the-pulpit, with its flattened base, slender stalk, and ruffled blossom.

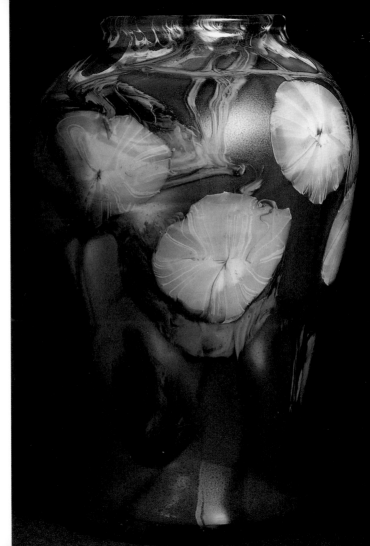

Morning glory
paperweight
c. 1900–10

In 1896, at the same time as it was developing its Favrile products, the Tiffany Glass & Decorating Company printed a promotional brochure entitled *Mosaics* in which Tiffany cited as his major influences for mosaics the spectacular interiors, frescoes, and tiled courtyards of Byzantine churches that he had visited as a youth. (Between 1898 and 1913, his team of mosaic artists grew from 12 to 56 people and occupied an entire floor of Tiffany Studios.)

Sound Byte:

"Mr. Tiffany runs a great art industry, a vast establishment combining under the same roof an army of all kinds united by a common current of ideas. It is perhaps by the audacity of such organizations that America will prepare a glorious future for its industrial art."

—SIEGFRIED BING, influential art
dealer in Paris and Tiffany's
European agent, 1896

In 1898, the company began experimenting with enamels, fabricated through the combination of glass and glass silicates colored with metallic oxides or a thin layer of gold or silver foil that would then be applied to copper and fired at high temperatures. The foil would reflect light through the various colors.

By 1899, his first leaded-shade lamps included the *Nautilus* and *Dragonfly* designs, followed shortly afterward by the *Wisteria* designs. [Note:

TIFFANY STVDIOS

Originality of Conception and Execution
endow the productions of the TIFFANY STVDIOS with an
artistic individuality which makes them particularly appropriate for

Holiday and Wedding Gifts

The stock now assembled in our studio show-rooms includes
exclusive productions in Lamps and Electroliers, Favrile Glass
in a variety of forms; together with many attractive articles
suitable for desk furnishings or boudoir appointments ✍ ✍ ✍

*Individual photographs sent when desired. Correspondence invited
Show-rooms open to visitors*

TIFFANY STUDIOS, 333 to 341 FOURTH AVE., NEW YORK
ONE SQUARE EAST OF MADISON SQUARE

Tiffany advertisement

Wistaria is the archaic spelling of *Wisteria*, the accepted current spelling. Both versions can be seen in the Tiffany literature, and, in fact, many Tiffany experts favor *Wistaria*.]

The 1900 Exposition Universelle in Paris was a triumph for Tiffany's domestic glassware production. Critics marveled at the wide range of shapes, colors, and textures he presented, and felt that his Favrile wares constituted his finest work to date.

The firm continued to introduce new techniques, as can be seen in three of the most successful series of that period: Tiffany's *Lava* vessels simulated the flow of molten gold lava ("volcanic glass") over dark blue basaltic rock, and his *Cypriote* series imitated the surface of vessels excavated from ancient archeological sites (e.g., Cyprus), in which the acids and alkalis in the soil had gradually decomposed and pitted the glass. His *Agate* pieces, in which layers of superimposed earth-tone colors of brown, cream, and yellow were cut into faceted patterns

that imitated those found on hardstones, were another innovation inspired by nature.

Throughout all this experimentation, an endless flow of crates, filled with functional household glassware—berry dishes, stemware, fingerbowls, etc.—was en route from Corona to retail stores across the country. Like most of the firm's operations, the production of domestic art glass became a mammoth and costly industrial undertaking that forced Tiffany to offer much of it at prices above that which the average homeowner—his professed client—could afford.

Lighting up the Lamps

Tiffany's lifelong fascination with light led him to introduce the first electric stained-glass lamps in 1899. By 1906, his company offered more than 125 types, ranging in price from $30 to $750, a consider-

FYI: **Tiffany's unique marketing plan—**An aggressive marketing campaign, with sales catalogues, pamphlets, magazine advertising, and press releases, was central to Tiffany's success. He had learned from his father the importance of promoting his wares at the great international exhibitions of the late 19th century, and he lavished time and money on preparations for those fairs as a way of attracting influential new customers.

able sum at that time. The bases for Tiffany lamps were usually cast bronze, while the shades were stained or blown glass.

The simplest lamps incorporate geometric designs, with panes of glass cut and arranged to represent the repeating elements in, for example, spider webs or lotus leaves or, in one very rare design, the decoration on an American Indian basket. In some lamps, the repeating elements consist of heavy glass lozenges called *turtlebacks* (because they resemble the backs of turtles), or the surface of the glass is covered with a filigree of metal, as if overgrown by vines. The *Nautilus* lamp, consisting of geometrically aligned glass elements shaped to form a nautilus shell, is a variant on this form where the lampshade itself takes the shape of the natural subject to be imitated.

More complex lamps, forming a transition between the purely geometrical and the purely floral shades, have a band of leaves or flowers. The most intricate lampshades, usually in a conical or domed shape, incorporate insects and flowers in an overall design, and include dragonflies, poppies, hydrangeas, daffodils, bamboo, roses, tulips, peonies, magnolia blossoms, and even a grape trellis or peacock feathers. In the most ambitious shades, the elements are arranged to evoke a garden dappled in light, with the suggestion of movement, as if a cool breeze were rustling through the leaves. In one butterfly lamp, the insects appear to spiral upward, perhaps on a warm current, perhaps attracted to the light, and the metal base is encrusted with an intricate floral mosaic.

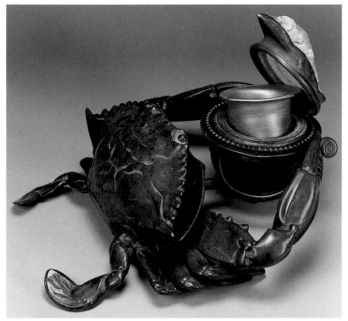

Crab inkwell
with gold
iridescent glass
inkpot

Vases and more

From about 1900 onward, the public knew Tiffany also as a maker of
extraordinary vases and accessory items ("fancy goods"), with some of
the vases glinting as if dipped in molten gold and others seemingly clad
in the iridescent plumage of peacocks or shaped like fantastic, unearthly
flowers or creatures.

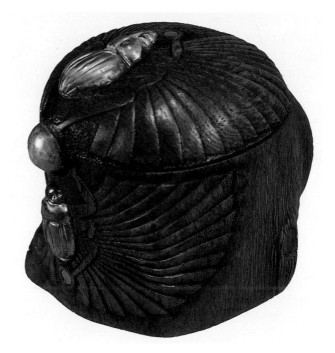

Hand-carved wood box with two iridescent glass scarabs and bronze hinge. c. 1901

Fame

Tiffany was at the peak of his career when he turned 52 in 1900. He had come to terms with being what one writer called, not without affection, a "super-salesman for an art-glass emporium," and was content to be the president of the highly successful Tiffany Glass & Dec-

orating Company, with well over 100 employees. He had given the world stunning new forms of stained and blown glass as well as several extremely opulent interiors—including the rooms inhabited by the president of the United States.

His family life was stable, if somewhat uneventful. He frequently walked his children to school before going to the office, but regretted that his second wife was reclusive and did not share his love of theater and nightlife. Whenever possible, he escaped his Manhattan office and piles of paperwork for the gritty, noisy Corona glass factory, where he played his greatest theatrical role as the alchemist, turning particles of common sand into golden-glass vessels or glowing windows, richer than rubies or emeralds.

A great Boss

Given the importance of teamwork in glassmaking, it is not surprising that Tiffany interacted closely with his employees and treated them well. Clara Driscoll, who was hired in 1897 and became a key designer for the company, was by 1904 earning $10,000 a year, which made her one of the most highly paid women in the country. Tiffany employed a high percentage of women in his studio, favoring them for their color sense and care in crafting the details of the increasingly intricate lamps and windows, but unless they held a top position like Driscoll, they earned less than the men.

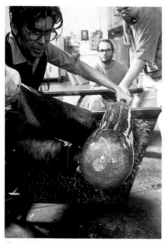

Photos in this section are courtesy, Dale Chihuly Studios

Gaffer and team,
Chihuly hot shop

Origins of glassblowing: Glassblowing has evolved from ancient techniques and traditional forms, and much of its vitality comes from adapting these processes and shapes to ever-changing tastes. The basic steps in making glass have remained essentially unchanged since the time of the Roman Empire, when glassblowing was invented.

The Hot Shop: Glassblowing is done in a hot shop. Although details varied over the years, in general the Tiffany factory contained 16 pots of colored glass or clear glass (lead glass if it was destined to be used in the production of blown vessels, or lime glass if it was intended for windows) organized around furnaces fueled with oil where the molten glass was held in the range of 2400–2600 degrees F. There were approximately 16 round heating chambers known as glory holes. Finished pieces were allowed to cool in ovens at a controlled temperature over a period of time to reduce tension within the glass.

The Team: Unlike other forms of art, such as painting or sculpture, hot glass requires teamwork. The person in charge of the piece being created is called the gaffer (or maestro). He or she is the team leader and has one or more assistants who blow the glass at the bench while the gaffer shapes the piece; they also shield the gaffer's arm and hand from the hot glass and bring bits of glass and punties (see section 5 below), prepare colors, and generally help out as needed. In Tiffany's factory, the teams had five to seven members, and during the 35-year production period for the factory there were eight head gaffers: Thomas Manderson, George Cook, James Grady, Arthur Saunders, John Hollingsworth, Thomas

Johnson, Joseph Matthews, and James Stewart. The teams, which were part of a union, could produce up to 30,000 objects a year, although the majority of pieces made were simple blown lampshades. Vases could be produced at the rate of roughly one per hour.

The Design: At Tiffany Studios, the design to be created was chalked onto a blackboard at the gaffer's station. A set of calipers (tools that resemble ice tongs) could then be set against the sketch to obtain the correct measurements for the object to be produced.

Tools: The glassblower's tools have remained virtually unchanged for hundreds of years. Most tools are made of steel or wood. Glassblowing tools are expensive; a basic set, including a blowpipe (i.e., a carefully machined, hollow piece of steel pipe that is the basic glassblowing tool), shears, and other tools, costs about $500 today.

Temperature: Glassblowing requires a dance between extremes of temperature. If the glass is too hot, it will flow like honey and lose its shape. If the glass cools down too much, it will become too hard to blow and may crack off the pipe and shatter on the floor. The gaffer must maintain an even temperature by constantly reheating the glass in the glory hole (or by using hand-held blowtorches), and by stopping the heating process before the glass becomes too "floppy."

Here's how it works:

(1) Mixing the ingredients: The raw materials for glass are silica (i.e., sand or quartz) and flux ingredients that make it easier to melt the silica by lowering the melting point of the

Blowpipes, Chihuly hot shop

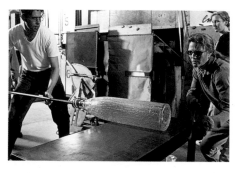

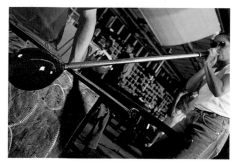

sand. (These ingredients also make the glass more resistant to decay and provide color and texture.) This batch is shoveled into a furnace where it can be melted into a liquid. At Tiffany Furnaces, the composition of the batch was overseen by a chemist and a mixer.

(2) Gathering the glass: The molten glass (i.e., glass that is hot and melted) is extracted from the furnace on the end of a blowpipe. This produces the first gather of glass. If you've ever removed honey from a jar with a wooden stick, you're familiar with this process. The blowpipe is continually rotated to keep the gather of glass centered, as with a glob of honey. It is possible at this or at later stages to add color to the glass (see section 8 below).

(3) Blowing bubbles: The first gather of hot glass is rolled on a steel table called a marver. A large, bullet-shaped, solid mass is created at this stage, thereby forming the beginning of the glass vessel. The glassblower breathes air into the blowpipe and a small bubble emerges at the other end, within the mass of molten glass. After the gather has cooled, additional layers of glass can be built up around the initial gather. Wooden paddles are used to flatten the end of the bubble, creating what will become the foot, or flat bottom, of the piece. Ladlelike blocks are used to shape a bubble into a perfect round shape. This stepwise

process enables the artist to coax the shape-less mass into an infinity of forms and sizes.

(4) Modifying by reheating: To prevent the vase from breaking apart, the gaffer will often hand his blowpipe to an assistant, who takes it to the glory hole for reheating. There, the rapidly cooling glass is softened by a blasting flame and made ready for reworking. The shape, exceedingly hot from the glory hole and rapidly slumping under the pull of gravity, can be adjusted by the skilled team. Any problems can be repaired at this time.

(5) The punty: Once the basic shape of a piece is established on the blowpipe, it is time to open up the mouth of the vessel. Steel or wooden tongs called jacks are used to disconnect the neck of a piece from the blowpipe and transfer it to a punty, also called a pontil rod. Unlike the blowpipe, which is hollow, the punty is made of solid steel and is used to hold the hot glass during the final stages of glassblowing. It is fused to the end of the gather, at the foot of the piece opposite the end to which the blowpipe had been fastened. Special scissors or shears can be used to cut the molten glass, trim the lip or mouth of the vessel, open up the bubble, and form the rim. If the vessel requires a handle, a foot, or some three-dimensional decoration, a studio assistant can bring a specially shaped solid bit of

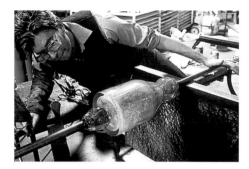

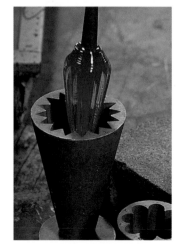

ABOVE
On to ponsil,
Chihuly hot shop

LEFT
Mold-blow,
Chihuly hot shop

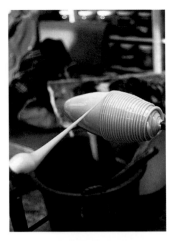

hot glass to the gaffer at the bench, where it is fused to the object being made and cut off with scissors. The open neck of the piece, where it had once been attached to the pipe, becomes the neck of the glass vase or the mouth of the bowl. Paddles are used to finish the mouths of vases and bowls once the piece is on the punty.

(6) Relieving stress points: When the process is judged complete, the finished vessel is cracked off from its pontil and goes into the annealer or lehr, an oven where, over a period of hours or days, high heat is slowly decreased to room temperature, and where the stresses that have built up in the glass from all the reworking are diminished. If the glass cools too rapidly, it will break or explode from the unrelieved stresses. It is not uncommon for glass to fracture in the annealer, despite these precautions.

(7) Finishing: Afterward, the glass is inspected and is cold-worked with special polishing and buffing equipment to repair damaged surfaces—for example, the removal of the pontil rod leaves a scar on the base of the vessel and this must be polished away. Finally, the artwork is signed and shipped, or stored for future sale. Not all original Tiffany artworks are signed, and not all signed Tiffany artworks are by Tiffany. Since his reputation continued to grow long after his death, forgeries became relatively common.

(8) Adding color: Color in glass can be very expensive because of the complexity of the chemical formulas and the scarcity of some ingredients such as gold and silver. Jimmy Stewart, a Tiffany gaffer, told of how some of the old broken pots of colored glass would be busted open, and the melt-

ed silver left over from the color-batching process extracted. At 35 to 40 cents an ounce, "if you had a tomato can full of that silver metal, you had a nice vacation, and that's what we used to do in the summertime." Because different metals heat and cool at different rates, not all colors are compatible. This means that even after a piece is blown and annealed, if incompatible colors are used, the glass may break apart on its own after it is taken out of the annealer. Much trial and error, and associated costs, go into producing a new series of vessels or sheets of stained glass.

Colors can be added to blown vessels at many stages in the forming process. At the Tiffany Furnaces, there were special pots in which different colors were melted, and the first gather could be of red, or blue, or white, etc. Additional layers of color could then be gathered on top of the first gather, or pressed into, dripped onto, or wound around the vessel.

Tiffany delighted in creating new textures and colors for stained glass, and in finding new ways to make glass richer and more interesting. For example, some of his best effects were achieved by ladling molten glass from the furnace or color pots and pouring it into puddles on the marver, where it might be shaped and twisted with various tools, until it resembled the folds in drapery or clothing.

(9) Some Tiffany "special effects": Striations are tonal gradations in the glass that give it the appearance of waves in the ocean or clouds in the sky. Mottled glass has speckles and dots that resemble the appearance of bacteria or amoebas under a microscope. Textured glass is perfect for imitating waves on water, or drapery folds. Fractured glass consists of a sheet of glass with irregular chips of broken glass melted into the surface, and is used to imitate the little blurry details of a landscape seen at great distance, such as a forest. Dichroic glass has one color in *reflected* light (e.g., murky green) and a completely different color in *transmitted* light (e.g., blood red). Dichroic glass adds great mystery to windows and lamps, giving them split personalities as day turns to night or a lamp is switched on and off.

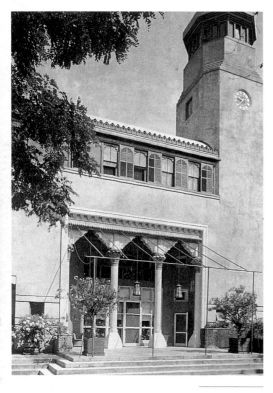

In 1901 Tiffany was chosen to create the adornments for the Yale Bicentennial celebrations, and he responded with a joyful mix that included waving flags, glowing Japanese lanterns, and the decorative use of evergreens. Many who attended the festivities congratulated Tiffany on his most effective decoration ever, and in 1903 Yale awarded him an honorary Master of Arts degree. It was especially gratifying to the artist who, as a young man, had taken a risk by avoiding college and turning to the arts for hands-on instruction. Sadly, his father did not live to see his son so recognized. Charles Tiffany had died on February 18, 1902.

Great Gatsby?

After his father's death, Tiffany purchased the mansion on 72nd Street from his father's estate and laid plans for a new country retreat to be built on a 580-acre tract at Cold Spring Harbor, near Oyster

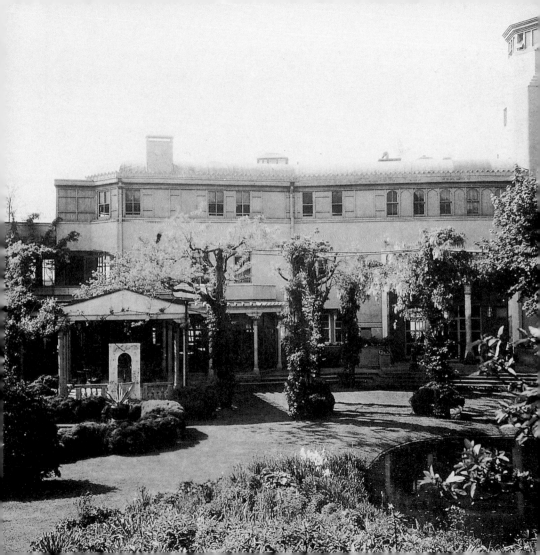

Bay on Long Island. Tiffany tore down the resort hotel on the site but kept its name of Laurelton Hall.

Laurelton Hall came at a time in his career when he was ready to combine his previous successes into a unified "trophy." Tiffany created a

house that was Persian in style but was inspired also by the designs of Pullman cars and steamships.

An artist with the soul of a gardener, Tiffany "painted" the terrain of his new estate with flowerbeds and decorated the capitals of the columns of the loggia with ceramic poppies on glass stems. Like many artists, he was fascinated with mechanical contrivances, and Laurelton Hall abounded with them, including an imposing bell tower with automated Westminster chimes.

Tiffany diverted a stream on the property so that it flowed through the house and emerged in a fountain court where the tamed water entered the bottom of a four-foot-tall Tiffany glass vase, sparkled from the top, and filled an octagonal basin.

Tiffany was an avid collector of everything from Japanese sword guards (he owned more than 4,000) to antique Indian baskets to his own works of glass, and Laurelton Hall became something of a museum, housing several of his most important personal works in stained glass. His interest in blending materials and functions and historical periods found expression everywhere, even in the smokestack of the powerhouse, shaped like a minaret with mosaic inlays.

When Tiffany moved into the splendid and expensive estate—the house alone cost about $200,000 to build in 1905—it was a melancholy moment, for his wife Louise, who had died the previous spring, was not there to share the family's joy.

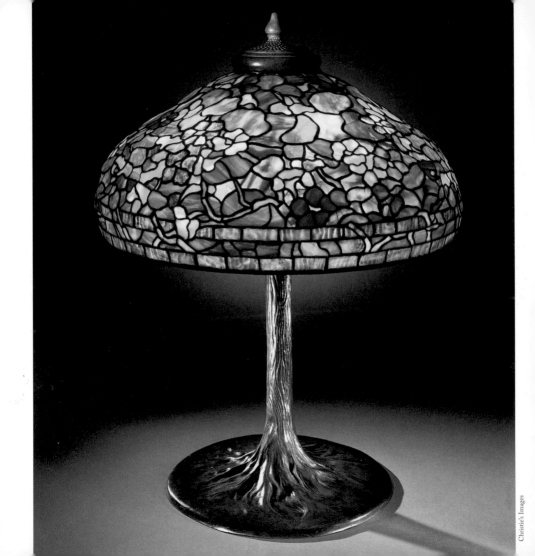

Dragonflies for her hair

Perhaps it was a mere coincidence of timing, but Tiffany, the master of the grand scale and of manufacturing large objects from small pieces, set out to create his smallest artistic creations—jewelry—at the same time that he was building his largest one, Laurelton Hall. After his father's death in 1902, Louis had become artistic director of Tiffany & Co. and had begun experimenting, secretly, to produce jewelry for the 1904 Louisiana Purchase Exposition in St. Louis.

The necklaces, brooches, and ornaments that Louis Tiffany created were eccentrically innovative. He often chose semiprecious stones based on their resemblance to glass. For example, he delighted in moonstones because they most resembled his beloved opalescent glass. His arrangements spurned the formal for the asymmetrical, and some of the mountings were platinum, a metal Tiffany was among the first to use in the service of art.

Nature was the overarching theme for his jewelry. It is likely that he was the first artist (or maybe the last?) to represent, with dignity, a pink flamingo on a necklace. Perhaps the most fabulous of these miniature artworks was a hair ornament (c. 1904), a little over three inches high, depicting two dragonflies resting on dandelion puffs, done in platinum and enamels with black and pink opals and garnets. The puffs are shown in a state of decay, as if about to blow away in the wind, while

OPPOSITE
Nasturtium leaded-glass and bronze table lamp

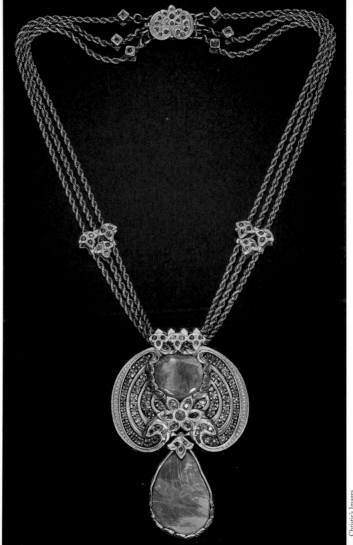

Black opal, demantoid garnet, sapphire and enamel necklace (front view)

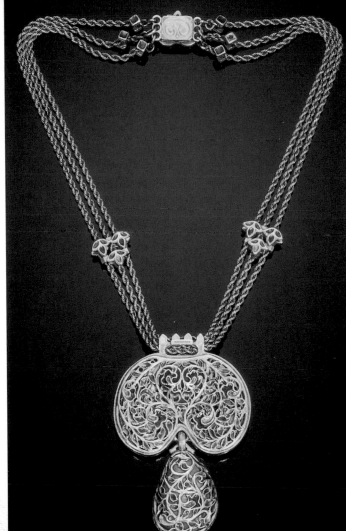

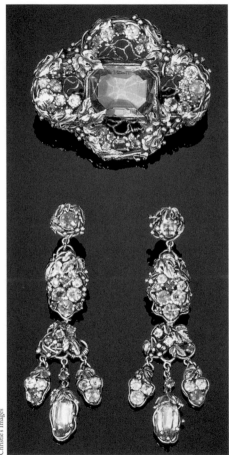

the platinum wings of the dragonflies are the most delicate openwork metal lattice imaginable. They are said to have been alloyed with iridium, a remarkably uncommon metal reserved even today for the most rarefied jewelry.

Projects of some scale

Tiffany production peaked around 1900–10, and went into decline around the time of World War I, stressed by the demands of the war effort and the emergence of new styles in art. Sadly, many of the churches that held Tiffany windows have disappeared. In 1911, Tiffany completed the mammoth fire curtain (still in use today) for the National Theatre in Mexico City—almost one million pieces of mosaic glass depicting the view of snow-capped mountains as seen from the President's Palace. In 1912, he created two of his best known domestic windows, for Captain Joseph R. DeLamar's home on Madison Avenue—the *Peacock* and

Cockatoo windows. Around this time Tiffany also created the *Bathers* window, which he later installed at Laurelton Hall. The window is famous for two reasons: It is supposed to have been Tiffany's most successful attempt to represent the human form in glass without the use of paint, and it was destroyed by fire in the conflagration that marked a symbolic end to Tiffany's pursuit of beauty.

"Come to me"

Tiffany was an incurable romantic. Late in life, at age 65, he produced the first of three dreamlike theatrical festivals—decades later, in the late 1960s and early 1970s, these kinds of events would be called *Happenings*—intended to convert the world to his own religion of beauty.

The first such event, held in 1913, was a costume party with an Egyptian theme, held at Tiffany Studios and announced by the delivery to each invited guest of a scroll in Egyptian hieroglyphics that read, in part: "Come to Me and Make Glad Thyself at the Sight of My Beauty" and signed by Queen Cleopatra. C. F. Theodore Steinway, an accomplished pianist who ran his family busi-

Louis Comfort Tiffany as an Egyptian potentate.

ness, Steinway & Sons, was engaged to write the music, and the room was designed to evoke the Royal Palace and harbor of the ancient city of Alexandria during Cleopatra's reign.

The opening procession of actors and actresses onto the stage brought rich treasures, including Tiffany Favrile glass, to display before the Queen. Cleopatra arrived, presenting to Mark Antony a splendid oriental rug, which, when unrolled, surprised the assembly with its contents: the dancer Ruth St. Denis, who, according to the press, enthusiastically performed "a ravishing dance of the Nile clad in the bronze costume given her by nature" for an audience that included the tycoon **John D. Rockefeller** (1839–1937) and Robert W. de Forest, president of The Metropolitan Museum of Art. It was quintessential Tiffany, an attempt to combine all the arts in the service of beauty, tinged with commercialism, and misunderstood by many as mere entertainment.

Thinking of the future

In 1918, Tiffany established the Louis Comfort Tiffany Foundation by deeding to it Laurelton Hall, all its contents, 62 acres of surrounding land, and an endowment of $1.5 million, a vast sum at that time. His purpose was to establish an institute for art education, appreciation, and production. The foundation opened in 1920 with a group of eight "students."

Over the years, a wide variety of painters, photographers, interior designers, and others spent from one to two months absorbing the beautiful atmosphere of Laurelton Hall. Instead of offering an environment with formal instruction, the program made available a succession of visiting artists. One of the students, Hugh McKean, would later become a champion of Tiffany during the time of declining public interest in the work. He rescued key Tiffany artworks from oblivion and established a splendid museum, the Morse Gallery of Art, to house them in Winter Park, Florida.

Decline

Tiffany retired in 1919, and his downward trajectory began soon there-after. It was as dizzying as his ascent had been half a century earlier. The studios were reorganized that year into Tiffany Furnaces for blown glass and the Tiffany Ecclesiastical Department for windows, lamps, etc. By 1924, Tiffany Furnaces was dissolved, and in 1932 Tiffany Studios went into bankruptcy. On January 17, 1933, Tiffany died, followed in 1934 by liquidation auctions. By 1938, the entire enterprise was gone.

Although the Tiffany Foundation still provides support for artists, it lost its way after Tiffany's death. In 1946, the contents of Laurelton Hall were sold at Parke-Bernet Galleries (now Sotheby's) and in 1957 Laurelton Hall was destroyed by fire.

Fire at Laurelton Hall. 1957

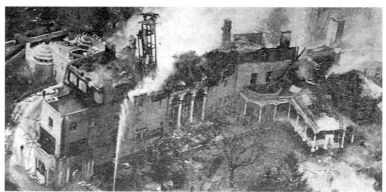

Almost all of Tiffany's New York City mansions and interiors have been razed since the time of his death. The glass screen at the White House had, of course, been "removed and broken into bits" as ordered by President Roosevelt long before, as if an omen of things to come. As America embraced Modernism and the Bauhaus, Tiffany lamps and blown glass—long out of fashion—were relegated to attics or flea markets or simply tossed into the trash. Tiffany was junked as kitsch.

Legend

The Tiffany revival began after World War II, at a time when Abstract Expressionism was seducing the art world with vibrant, free-form color. Artists like **Jackson Pollock** (1912–1956) were inspired by Tiffany's willingness to let glass flow freely, without regard to the

Louis Comfort Tiffany. c. 1922

restrictions of subject matter, into novel patterns and shapes. For example, Tiffany Lava vases might have begun as an attempt to imitate the flow of lava, but they ended up as glorious abstractions.

A new generation of dealers and curators was ready to take the Art Nouveau style—and Tiffany—seriously. Leading the way were Edgar Kaufmann, Jr. (who, as a young man, had talked his parents into taking a chance and hiring architect Frank Lloyd Wright to build a country house for them that would be called *Fallingwater*—and who had become a supporter of Tiffany's work while he was at The Museum of Modern Art) and the antiques dealer **Lillian Nassau** (1900–1995), who recognized that Tiffany lamps were superb softeners for harsh modern interiors. Works of Tiffany were sold to the Beatles, Catherine Deneuve, and David Geffen. Soon, collectors ranging from John W. Mecom, Jr., the Houston oil heir, and actor Brad Pitt—who favored the earlier Tiffany turtleback and Moorish lamps—were competing for the precious antiques and sending prices ever upward. The Macklowe Gallery in New York City is now considered to be among the world's preeminent Tiffany dealers, and David Bellis, of New York, owns one of the world's

finest private collections of Tiffany glass. Many of the pieces in his collection were exhibited in "Masterworks of Louis Comfort Tiffany" at The Metropolitan Museum of Art and at the Smithsonian in 1990.

Museums took notice as well, beginning in 1958 with the first major retrospective exhibition of Tiffany's work at the Museum of Contemporary Crafts in New York. By the 1980s and early 1990s, the Corning Museum of Glass, The Metropolitan Museum of Art, and the Smithsonian Institution had all held major exhibitions of Tiffany's work. In Japan, a private collector, Takeo Horiuchi, passionate about Tiffany, opened a museum in Nagoya with a splendid group of the artist's masterpieces.

Conclusion

Tiffany explored the world of glass and decorative arts at the same time that **Jules Verne** (1828–1905) wrote *20,000 Leagues under the Sea*. One can imagine that the Tiffany *Nautilus* lamp might have been welcome aboard the submarine of the same name. Tiffany's interiors were in fact Vernian in scope; he produced ensembles that allowed the occupants of the rooms to explore the world from their armchairs. For example, in the Armory room, veterans could relive the memories of life in a military encampment; at Laurelton Hall, the stream was brought into the house, where it became a fountain and the guests could enjoy it and organ music simultaneously, while overhead shimmered a blue sky made from Tiffany iridescent glass tiles.

Tiffany's concept of the total environment was a fascinating precursor to the *installation art* of the last half of the 20th century, even if it was frequently criticized for being cluttered or excessively ornate. Here was an artist who used extravagant materials in the service of high art (as in the Rembrandt room for the old master paintings at the Havemeyer house) but was eager to learn from the "circus arts" as well, such as interiors found on showboats or in Pullman train cars. We can enjoy Tiffany's art for the sole pleasure of its richly intense colors, or we can be mesmerized by the harmonies of those colors and transported to a more spiritual, more dignified state of mind.

OPPOSITE
Dragonfly table
lamp c. 1900–10
33" (81 cm)
high x 22 4/5"
(56 cm) diameter

The Essentials of Tiffany

Here are some key points to remember about the art and innovations of Louis Comfort Tiffany:

- He was an alchemist with materials, never afraid to persevere until his ideas were captured in glass, bronze, fabrics, or stone, even if this required the invention and patenting of a new process.

- He tamed electric light and tempered its harsh rays with filters of colored glass.

- He loved the theatrical aspect of life and sought to capture it in his art, with wildly exaggerated colors and forms in his glass and with highly dramatic interiors in his houses.

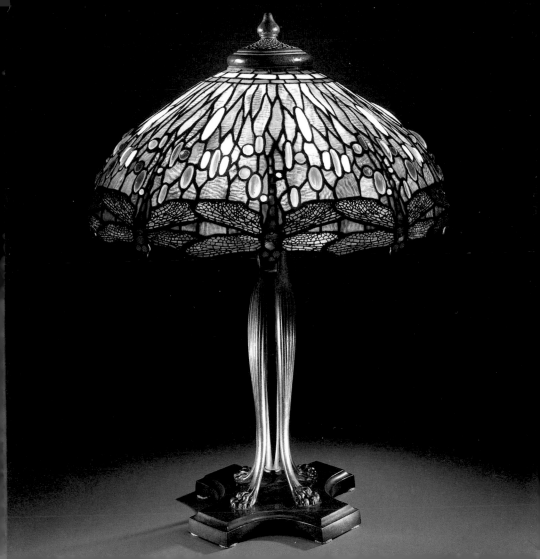

- He saw himself as the first industrial artist and was not afraid to use the techniques of mass production, provided that the end results were beautiful.

- He elevated glass to the realm of art by making it sparkle like the most expensive gemstones.

His Legacy

Tiffany was passionate about beauty as a humanizing force in life and expressed this exuberance through his search for beauty in all things. He allowed his team of artists and craftspeople the challenge of experimentation and ambition in their work, so that they might seek the ever-elusive goal of the ensemble or total environment. In his treatment of his employees, although limited by the customs of the time, he acknowledged the need for kindness and courtesy, and in his recognition of women and willingness to promote them to positions of leadership, he was progressive for his era. With the establishment of a foundation, he sought to return to the world a gift of thanks for the success he had achieved.

So that is Tiffany: An artist born to fortune who loved the commonplace and who believed that he could harness a factory to create objects of beauty. Tiffany's decline and rehabilitation teach us that when we reject an object of beauty because it does not adhere to the tastes of a prevailing artistic movement or theory, we are closing off the most basic experience of art—namely, that art should enter through the portals of the heart, not the mind.

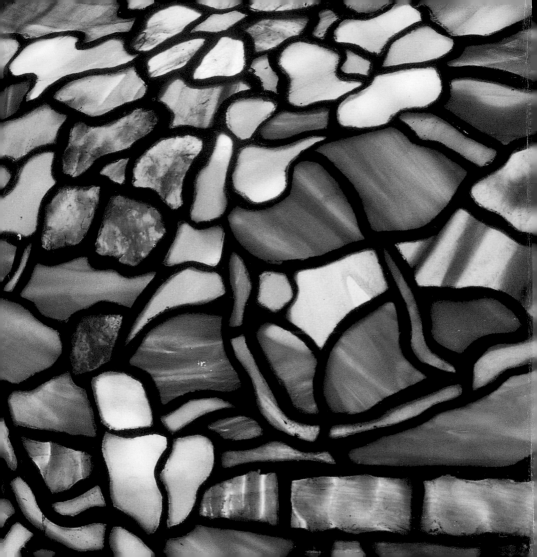